The World's Great
Masterpieces of Art

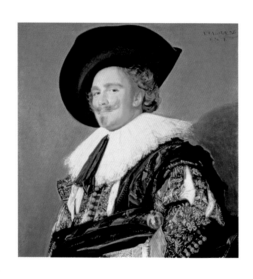

Publisher and Creative Director: Nick Wells
Senior Project Editor: Catherine Taylor
Art Director: Mike Spender
Layout Design: Jane Ashley
Digital Manager: Chris Herbert
Special thanks to: Chelsea Edwards, Polly Prior, Laura Bulbeck and Frances Bodiam

FLAME TREE PUBLISHING

Crabtree Hall, Crabtree Lane
Fulham, London SW6 6TY
United Kingdom

www.flametreepublishing.com

First published 2015

15 17 19 18 16
1 3 5 7 9 10 8 6 4 2

Image credits: Courtesy of **Bridgeman Images** and ©: 36, 46 Galleria degli Uffizi, Florence, Italy/Giraudon; 37 Scrovegni (Arena) Chapel, Padua, Italy; 38 Museo dell'Opera del Duomo, Siena, Italy; 40, 45, 52, 63, 68, 70, 81, 83, 96, 97, 100 National Gallery, London, UK; 41, 47, 76 Prado, Madrid, Spain; 42 Koninklijk Museum voor Schone Kunsten, Antwerp, Belgium/Giraudon; 43, 65 Prado, Madrid, Spain/Giraudon; 44 Brancacci Chapel, Santa Maria del Carmine, Florence, Italy; 48, 61, 64, 78 Louvre, Paris, France/Giraudon; 49 Staatliche Kunstsammlungen, Dresden, Germany; 50, 51 Vatican Museums and Galleries, Vatican City, Italy/Alinari; 53 Galleria degli Uffizi, Florence, Italy; 54 Pinacoteca di Brera, Milan, Italy; 55 Toledo. S. Tome, Spain/Giraudon; 58 National Gallery, London, UK/Giraudon; 59 Onze Lieve Vrouwkerk, Antwerp Cathedral, Belgium; 60, 71 Wallace Collection, London, UK; 62 Rijksmuseum, Amsterdam, The Netherlands; 66 Mauritshuis, The Hague, The Netherlands; 67 Courtesy of the Trustees of Sir John Soane's Museum, London; 72 Detroit Institute of Arts, USA/Founders Society purchase with Mr and Mrs Bert L. Smokler; and Mr and Mrs Lawrence A. Fleischman funds; 73 Musées Royaux des Beaux-Arts de Belgique, Brussels, Belgium; 74 Private Collection; 75 National Gallery of Scotland, Edinburgh, UK; 79 Hamburger Kunsthalle, Hamburg, Germany; 80, 82 Louvre, Paris, France; 86 Musée d'Orsay, Paris, France; 87 Birmingham Museums and Art Gallery, UK; 88, 89, 91, 92, 99 Musée d'Orsay, Paris, France/Giraudon; 90 Musée d'Orsay, Paris, France; 93 Samuel Courtauld Trust, The Courtauld Gallery, London, UK; 94 Private Collection/Photo © Christie's Images; 95 The Art Institute of Chicago, IL, USA; 101 Museum Folkwang, Essen, Germany; 102 Österreichische Galerie Belvedere, Vienna, Austria; 103 Chagall ®/© ADAGP, Paris and DACS, London 2015/; Museum of Modern Art, New York, USA; 104 Succession Marcel Duchamp/ADAGP, Paris and DACS, London 2015/; Philadelphia Museum of Art, Pennsylvania, PA, USA; 105 ADAGP, Paris and DACS, London 2015/Musée National d'Art Moderne,; Centre Pompidou, Paris, France/Giraudon; 106 Art Gallery of Ontario, Toronto, Canada/Gift of Sam and Ayala Zacks, 1970; 107 DACS 2015/Art Gallery of Ontario, Toronto, Canada/Gift of Sam and Ayala Zacks, 1970; 108 Musée National d'Art Moderne,; Centre Pompidou, Paris, France/Giraudon; 109 Successió Miró/ADAGP, Paris and DACS London 2015/; Albright Knox Art Gallery, Buffalo, New York, USA; 110 Hamburger Kunsthalle, Hamburg, Germany/Gift of Friends of Carl Georg Heises; 111 Des Moines Art Center, Des Moines, Iowa, USA; 112 ADAGP, Paris and DACS, London 2015/Galerie Daniel Malingue, Paris, France; 113 Private Collection/Giraudon; 114 Salvador Dali, Fundació Gala-Salvador Dalí, DACS, 2015/; © Museum of Modern Art, New York, USA; 115 2015. Banco de México Diego Rivera Frida Kahlo Museums Trust, Mexico, D.F./DACS/Private Collection/Photo © Christie's Images; 116 Succession Picasso/DACS, London 2015/Museo Nacional Centro de Arte Reina Sofia, Madrid, Spain; 118 The Willem de Kooning Foundation, New York/ ARS, NY and DACS, London 2015/Museum of Modern Art, New York, USA; 119 ADAGP, Paris and DACS, London 2015; 120 The Pollock-Krasner Foundation ARS, NY and DACS, London 2015/; National Gallery of Australia, Canberra; 122 2015 Kate Rothko Prizel & Christohper Rothko ARS, NY and DACS, London/Museum of Fine Arts, Houston, Texas, USA; 123 The Estate of Roy Lichtenstein/DACS 2015/Scottish National; Gallery of Modern Art, Edinburgh, UK; 124 ADAGP, Paris and DACS, London 2015/Private Collection; 125 2015 The Andy Warhol Foundation for the Visual Arts, Inc./Artists Rights Society (ARS), New York and DACS, London. Trademarks Licensed by Campbell Soup Company. All Rights Reserved/ Wolverhampton Art Gallery, West Midlands, UK; and courtesy public domain/**Wikimedia Commons**: 98.

ISBN 978-1-78361-214-7

Printed in China

The World's Great
Masterpieces of Art

Michael Kerrigan

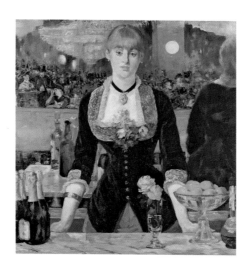

**FLAME TREE
PUBLISHING**

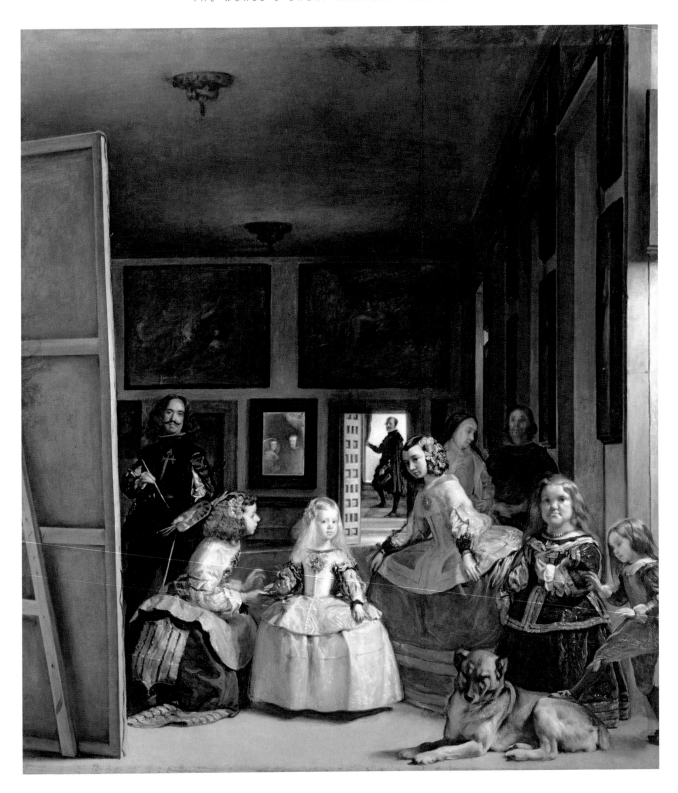

Contents

Great Art: Masterpieces Across the Centuries

Art is eternal. But not eternally the same: down the millennia, it's developed – along with humankind. Even so, some sort of 'tipping point' was reached with the medieval age: since then we've seen an avalanche of change. Clear continuities can be traced: whilst the support of Church and monarchy has been supplanted by that of secular and civic patrons, important ceremonial and status-conferring functions have endured. The transformation has been decisive, even so: everything from the first pioneering of perspective to the exploration of the 'subconscious' and the idea of 'abstract' art; from the cult of 'originality' to the appreciation of beauty as a value in its own right.

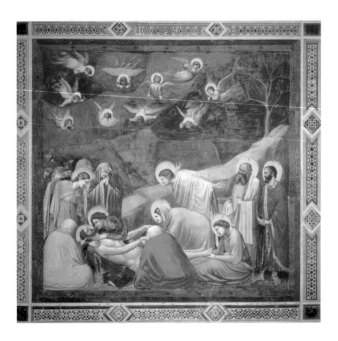

GOTHIC & MEDIEVAL ERA

It was the art historian and pupil of Michelangelo, Giorgio Vasari, who, in the sixteenth century, coined the term 'Gothic' to describe the art and architecture of the Middle Ages. This label has remained to describe the fantastic spires and grotesque ornament of cathedrals, as well as the style in stained glass, tapestry and the applied arts. It found expression in the fine arts of the fourteenth and fifteenth centuries, mainly through the medium of the richly illuminated books of hours and other devotional works.

Byzantine Art

The art of Byzantium seems mysterious to us today, moving though it is in its quiet spirituality. The ravishing mosaics and exquisite icons created at that time set the tone for a medieval 'age of faith' in which it went without saying that the primary function of the fine arts was religious.

The Byzantines regarded themselves as Romans: the heirs of the Caesars, and still very much in business. In historical hindsight, however, it does not seem so simple. Their capital had originally been established (around 600 BC) by merchant–adventurers from Greece; its Greek identity had only strengthened since. So, too, had the Eastern influence: the city on the Bosphorus had been a headquarters for trade with western Asia, and the traffic had been not only commercial but also cultural. Above all, Byzantium was Christian: its rise in the first millennium had coincided with that of the early Church. All these influences made their presence felt in Byzantine art, starting with a sense of proportion and symmetry inherited from the Greeks and Romans.

The most favoured Byzantine media – mosaic and painting (panel or wall pictures) – were also drawn from classical tradition. What sets Byzantine art apart, however, is its luminosity: that astonishing radiance which shines forth from the great mosaics and religious portraits or icons (often achieved by the actual use of gold). The glory of God was embodied in art just as His Word had been 'made flesh' in Christ. Since the painter saw himself as merely the instrument of divine inspiration, he was typically anonymous.

Romanesque Art

Western Europe lagged behind in the eleventh and twelfth centuries: the region's art is known as 'Romanesque' because it modelled itself on what it saw of Roman styles – both in the ruins of the western empire and, ongoing, in Byzantium. The divergence between West and East was underlined by the Great Schism of 1054, when the Orthodox Church finally broke with Rome. Catholic Europe saw itself as true keeper of the Christian tradition, but it was definitely the junior partner in the arts.

Here, too, the primary inspiration was religious and, indeed, much art was actually produced by monks. Moreover, we find again a close association between artistic image and divine Word; and nowhere closer – or more splendidly – than in the 'illuminated' manuscripts turned out in monasteries. Bibles, Psalters (books of Psalms), saints' lives, 'books of hours' (which set out the different prayers and services for the different times of day), etc. were all books which still had to be written out by hand, but the labour became one of deep love and miraculous beauty. Initial letters were so elaborately and colourfully ornamented as to become magnificent works of art; marginal illustrations offered a quirky commentary on the accompanying text.

Books were only for the lettered few, but art was, if anything, more important for the masses. Paintings gave the illiterate poor a visual scripture. Complementing the wood carvings, stone sculptures and

stained-glass windows also appearing at this time, brightly coloured murals located inside churches set out stories – often in cartoon-strip sequence, they depicted edifying scenes from the Bible or the lives of the saints, or terrifying representations of the Last Judgment and the agonies of Hell. Such examples as have survived are striking for their narrative interest and vivid colour. Conceived for propaganda purposes rather than to prompt private reflection, they show less sheer luminosity, less sense of mystery than the Eastern icons and less concern with the idea of contemplation for its own sake.

Gothic Art

The description 'Gothic' was originally a sneer on the part of the artists and architects of the Renaissance, who saw their predecessors' work as crude in the extreme. Inspired by classical models, they could think of no barbarity greater than the sack of Rome, carried out by the Goths – a Germanic people – in AD 410. Now the thirteenth and fourteenth centuries seem something of a golden age with their incredible cathedrals: awesome in their scale, mesmerizing in their complexity and grace.

The great Gothic cathedrals were collective efforts built by self-effacing craftsmen. As with the great Byzantine icon painters, we do not know their names. In the late thirteenth century, however, we do begin to see signs of a sense of individualism in the field of painting, as particular masters start to stand out from the crowd. From about the 1270s in Florence, the studio of Cimabue (c. 1240–c. 1302, see page 36) turned out a series of superb frescoes – wall paintings so called because they were created quickly on fresh plaster before it dried. The Byzantine influence in Cimabue's work is evident in his use of gold and mosaic, and in his unashamedly stiff and stylized forms; we see a far more natural sense of life and movement in the frescoes of his student Giotto di Bondone (c. 1267–1337, see page 37).

That naturalistic impulse was picked up by artists through the fourteenth century. The Dutch-born Limbourg brothers, Herman, Paul and Jean, started out as skilled illuminators. Working around 1400, they transferred their skills to painting, creating miniatures whose fresh vividness was emulated by Western European artists from Burgundy to Britain. Even religious works showed everyday scenes in lively detail – though often in counterpoint with more rigid Gothic arches and other architectural forms. The artists' technical mastery, displayed in details such as the contours of a face or a fold of drapery, brought both a more human and a more sophisticated, elegant feel. The new aesthetic inspired another illuminator-turned-painter: France's Jean Fouquet (*c.* 1420–81, *see* page 42).

Schools of Gothic Art

It is tempting to see the story of medieval Italian art as one of inevitable 'progress' towards an absolute standard of realism, but that transition came with costs as well as gains. Some sense of what was potentially being lost can be had from the works of artists in the city of Siena, where the spirit of Byzantine icon-painting lived on. The impressive canvases of Duccio di Buoninsegna (*c.* 1255–*c.* 1319, *see* page 38) may seem stagy and static, but, at the same time, as his student Simone Martini (*c.* 1284–1344) appreciated, they simply shimmer with mystic power.

In Belgium and the Netherlands, painters pursued ever greater realism, creating works of arresting intimacy. Jan van Eyck (*c.* 1389–1441, *see* page 40) is outstanding for the warmth with which he represented real men and women in their homes; Robert Campin (1378–1444) brought naturalism to new heights in his interiors and his human forms. Whether in private portraits or formal religious works, Rogier van der Weyden (1399–1464, *see* page 41) achieved an emotional immediacy which had not been seen before.

Such paintings have a quiet sobriety; they show none of the wild abandon we associate with Gothic architecture, with its flying buttresses and gargoyles. That sensibility was still there, though, and we see it in the visions of Hieronymus Bosch (*c.* 1450–1516, *see* page 47). Hellishly comic, his works seem like a troubled subconscious beneath the orderly sensibility of late medieval art, product of an 'age of faith' which was also an age of fear.

RENAISSANCE ERA

The Renaissance era was marked by an unprecedented flowering of the arts and literature as well as the beginning of modern science. In the fields of fine arts and architecture, the Renaissance had its greatest impact in Italy. Significantly, it was in the great mercantile centre of Florence, rather than the religious centre of Rome, that the movement developed initially, and it was in the liberal world of the merchant princes that the new art flourished most vigorously.

As the fifteenth century wore on, confidence was growing steadily, especially in the great city-states of Italy. Trade between them was flourishing, as was commercial (and cultural) contact with the wider world – Florence in particular had grown wealthy through its wool trade.

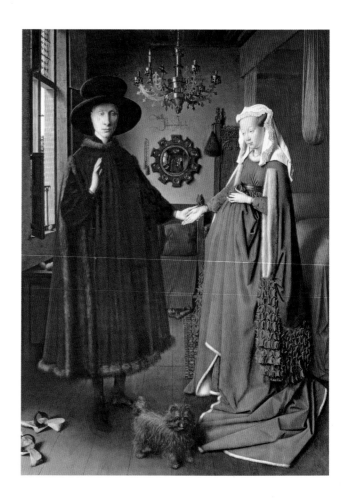

The confidence of the cities was strengthened by their freedom: Florence was a republic in its own right.

Florence

Even though Florence enjoyed great freedom, it was still not what we would call a democracy, as powerful magnates ruled the roost. But they owed no allegiance to kings or emperors: they were independent, and very proud of it. The local de' Medici family boosted both its own and its city's prestige by commissioning handsome buildings and beautiful works of art. Poets and scholars, too, found patronage: wealthy nobles across central Italy vied with one another in surrounding themselves with the most sophisticated and creative courts they could.

Men of art and learning could hold their heads up high: the feeling naturally boosted their self-esteem, but it also enhanced their sense of what man might be capable of in general. 'Humanism', as articulated by scholars such as Marsilio Ficino (1433–90), saw the human form as the height of physical perfection and the human intellect as the ultimate earthly reflection of the divine. Looking beyond the established orthodoxies in medieval thought – which saw humanity's function as very much to obey divine and ecclesiastical authority – it found inspiration in the achievements of classical Greece and Rome. Albeit now in a ruined state, the monuments of these civilizations still stood in their midst: they marvelled at their grace and symmetry. The name 'Renaissance' (the French for 'rebirth') was given to this great artistic, cultural, philosophical and scientific gear shift only subsequently, but it does not seem unduly extravagant in its implications.

At the time, though, it must have seemed more like evolution than revolution: the Church remained enormously important as a patron and Giotto's religious works still cast their spell. It was natural, then, that this medieval painter's hometown should have been an important centre. In Florence, his frescoes were everywhere a young artist might care to look. Religious in their subject matter, the works of Fra Angelico (c. 1395–1455, see page 43) may be wonderful in their warmth and human interest, but they clearly owe much to Giotto in their style. Tommaso Masaccio (1401–28, see page 44) too was a student of Giotto. Yet he studied Roman works as well and parted company with his medieval

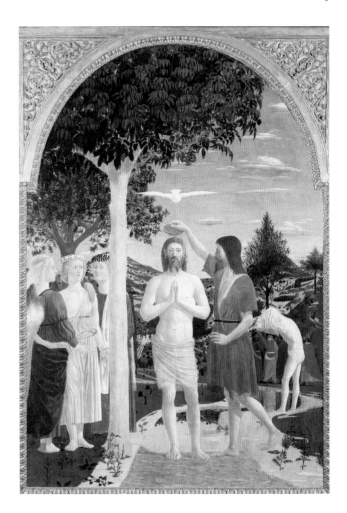

master by introducing ideas of scientific perspective to his art. Paolo Uccello (1397–1475) and Piero della Francesca (c. 1420–92, see page 45) actually enjoyed considerable reputations as mathematicians – their paintings employ geometry and perspective to give a new and powerful sense of depth.

By the late fifteenth century, the wind of the Renaissance was blowing strongly and bringing new trends, such as the idealization of the human form, a new and more scientific eye for nature, and classical inspiration (and a 'Neo-Platonist' attempt to marry Christian concepts of grace, godliness and virtue with ancient Greek philosophical ideas, such as those of Plato). All these are displayed to ravishing perfection in the famous works of Florence's Sandro Botticelli (1445–1510, see page 46).

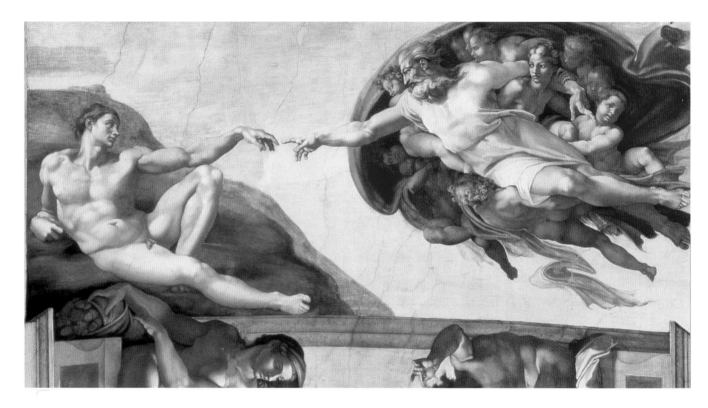

Rome

The papacy at this time was an immensely important institution –
and not just spiritually (not even spiritually, critics sneered), but also
temporally: the Church had huge political influence and vast wealth.
Accordingly, the Holy City exerted a strong cultural pull. Increasingly,
ambitious artists flocked there to find commissions. One who made the
grade was Michelangelo (Michelangelo di Lodovico Buonarroti Simoni,
1475–1564, *see* page 51): primarily a sculptor, but a painter at Pope
Julius II's request. It was for the pope's newly built Sistine Chapel that
Michelangelo spent four years (1508–12) painting the ceiling, among the
undoubted glories of Western art. It was in Rome as well that Raphael
(Raffaello Sanzio da Urbino, 1483–1520, *see* page 50) created his
greatest works – extraordinary in their humanity and grace.

Venice

Venice was a great seaport: looking outward to the Adriatic and the world
beyond, it was more cosmopolitan than the other Italian cities. From

here, Marco Polo had set out on his travels to China in the fourteenth
century and contacts had continued – albeit indirectly and intermittently
– ever since. Only now are Western scholars coming to appreciate the
cultural implications of this commercial connection, such as the
influence of Eastern silks and ceramics, on the decorative arts in Europe.

The consequences for the 'fine arts' are harder to assess: artistic
conventions in both East and West were strong. It is intriguing, though,
to think that China was undergoing something of a renaissance itself
during the Ming Dynasty (1368–1644), with artists such as Tang Yin
(1470–1524) and Qiu Ying (*c.* 1494–1552) creating works of
irresistible freshness and enterprise. It is in a Venetian painting of
1513, by Giovanni Bellini (*c.* 1430–1516), that we find the first known
representation of Chinese porcelain – a beautiful blue-and-white bowl –
in Western art, but there is no obvious indication of any more serious
artistic engagement, either in Bellini's work or in that of his successor,
Giorgione (Giorgio Barbarelli da Castelfranco, *c.* 1478–1510, *see* page
49), who is considered one of the greatest and most enigmatic figures
in Venetian art.

High Renaissance Art

The 'High Renaissance' conventionally begins with Leonardo da Vinci (1452–1519, *see* page 48) – not just a celebrated artist but an all-round 'Renaissance Man'. It was in keeping with humanist ideals that the individual should cultivate every possible accomplishment and skill: the man who created the *Mona Lisa* and the *Madonna of the Rocks* was also a musician, an engineer, an anatomist, a geologist, a writer and much else besides.

The Renaissance values of regularity and balance, and the skills of perspective, had by now become pretty much instinctual for artists: the sheer technical assurance available was staggering, hence, the virtuosity of the Florentine painter Andrea del Sarto (1486–1530) and the effortlessness with which 'Andrea senza errori' ('without errors') could breathe life into his human forms. There was still scope for artistic improvement, though: it took the Venetian Tiziano Vecellio, or Titian (*c.* 1485–1576, *see* page 53) to recognize the possibilities for exploring colour, in all its depth and warmth. A red-headed beauty is still spoken of as 'Titian-haired'; his fellow painters were to find that Titian's use of colour had opened up a whole new dimension in their art.

Northern Renaissance Art

Further north, in the Netherlands and Germany, city states were prospering through trade and industry, very much as the Italian cities had done before. The 'Northern Renaissance' lagged a little way behind, but the artistic, scientific and intellectual revolution it brought with it was every bit as far-reaching. (Ultimately, it might even be said that it went still further, with Martin Luther's Reformation of 1517.) Artists here had long gone their own way: Italian painters had been impressed by the work of earlier Dutch artists such as Jan van Eyck, but there had been little sign of the compliment being returned. Over time, however, as commerce between the two regions grew, things began very gradually to change.

In the Low Countries, centres such as Antwerp, Brussels and Bruges were booming on the back of the international trade in woollen textiles – and, increasingly, in finance. What has been described as the 'first modern economy' was under construction here. As in Italy, local patriotism was strong: wealthy magnates were anxious to boost their communities' prestige.

By the early sixteenth century, Antwerp had emerged as the region's richest city. The Gothic spirit was still strong, however, and most painters of the 'Antwerp School' worked anonymously, as their medieval predecessors had. Change was afoot, however, in artists' attitudes both to themselves and to their subject matter. Flemish painters often seemed as fascinated by landscapes and interior settings as they were by people. Joachim Patinir (*c.* 1480–1524) won renown for big and panoramic landscape paintings in which the human figures are often all but lost. The great, crowded canvases of Pieter Bruegel the Elder (*c.* 1525–69) could

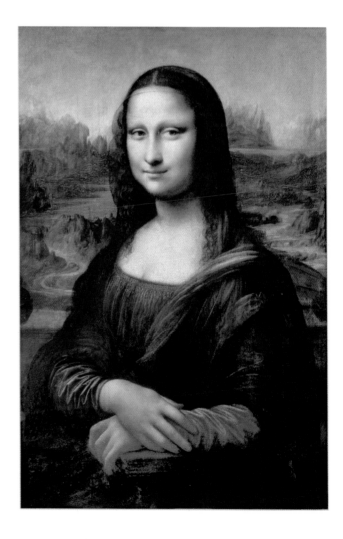

hardly be more crammed full of 'human interest' – both comic and disturbing – yet, at the same time, there is a cartoon-like quality about the men and women shown.

The industrious city states of Germany were thriving too, as their leading citizens acquired unprecedented wealth and with it that self-confidence and independent-mindedness which was eventually to bring about the Protestant Reformation. It helped that education was so much more widely available than it was in southern Europe, thanks to the new medium of print. Johannes Gutenberg (c. 1400–68) pioneered the use of movable type; his 'Gutenberg Bible' was published in about 1455.

Printing and illustration were a natural focus for German artists: woodcuts and engraving were developed to a high degree. Albrecht Dürer (1471–1528) started out this way, but his interests quickly broadened and he developed as a painter. He made a couple of Italian tours (1494–95 and 1505–7), finding a special inspiration in the works of Bellini. In addition to being a student of Italian painting, he was also an ambassador for German art, causing something of a sensation in Venice on his second tour.

Protestantism presented a whole new challenge to the visual arts, given its rejection of anything suggestive of the 'graven image' or the icon. At the same time, the emphasis it placed on the individual conscience lent a new significance to the feelings of real men and women. Lucas Cranach the Elder (1472–1553) often viewed such subjects through a mythological prism, using characters from classical legend to represent moral types. But he also renewed the art of portraiture, showing a special awareness of what would later be called the 'inner life'. Cranach's work was developed still further by Hans Holbein the Younger (1497–1543, see page 52), who is now most famous for the portraits he made at the court of England's Henry VIII.

Mannerism

When we say that a style of writing or behaviour is 'mannered', we mean that we think it artificial and exaggerated; that style has, in a certain sense, taken over. That is not necessarily a bad thing in art: it may just be different; the need to be 'natural' can be overstated. This is certainly the case when we consider the works of many of the painters of the late Renaissance period – great artists, without a doubt, yet clearly after something other than 'realism'.

The Venetian Tintoretto (Jacopo Comin, 1518–94, see page 54) is one example: the all-but-crazy energy and audacity of his paintings earned him the nickname Il Furioso. Strikingly dramatic, his work frequently shows little regard for the conventions of colour or the regularities of perspective, yet its greatness is unmistakable nonetheless. Paolo Veronese (1528–88), though born in Verona, moved to Venice in the 1550s. Here he seems to have felt emboldened to start producing ever more outrageously colourful and stylistically adventurous paintings. Cretan-born and trained to begin with in the post-Byzantine tradition of icon-painting, Doménikos Theotokópoulos (1541–1614) held on to some of its values and techniques in his later work. Known as El Greco (see page 55), 'the Greek', by his Spanish patrons, he courts absurdity – with the elongated figures and faces, the swirling backgrounds and the eccentric colours – in works which, at the same time, have an awe-inspiring profundity and power.

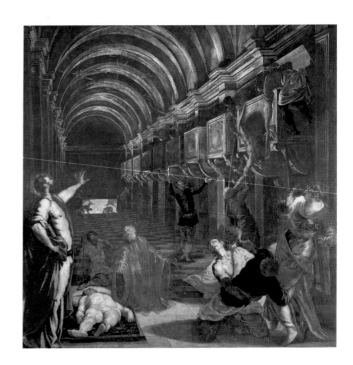

BAROQUE & ROCOCO ERA

The term 'Baroque' was applied to a style in art and architecture very fashionable in the seventeenth century and distinguished by extravagant forms and ornamentation, which became so elaborate as to verge on the grotesque. A new naturalism would later lead to greater realism and the vogue for landscapes in the eighteenth century. Rococo, fashionable in the same period, was light and frivolous. It captivated the French and spread rapidly to Italy and other parts of western Europe. In painting, it was reflected in the love of nature and the rise of the landscape, but it also impacted on the great allegorical compositions, especially ceilings and murals.

Martin Luther's stand at Wittenberg sent a spiritual shock wave through Western culture. The Catholic Church was taken completely by surprise. And it was not just that Luther and his followers had raised important theological objections to Catholicism – or that they had identified clear abuses in the institutions of the Church. Protestantism offered the believer much more, it seemed: not just a hierarchy to obey and a code to which to conform, but a living, breathing and completely transforming faith. Visionaries within the Church could see the need for dramatic and far-reaching changes which would make the Catholic creed more personal, more passionate and more relevant to ordinary men and women – hence what is now known as the 'Counter-Reformation'.

Italian Baroque

With the new spirituality came a new aesthetic: religious art was to be arresting; it should assault the senses and take the soul by storm. Though classically simple in its essentials, 'Baroque' architecture was exaggeratedly grand; rather than trying to emulate the modest simplicity of the Protestant chapel, churches proclaimed the transcendent glory of the one true faith. When you stepped inside, you were halfway to heaven, bowled over by a bewildering array of spectacular sculptures and paintings, as thrilling in their virtuosity as they were overwhelming in their emotional force. The Romantic movement of the nineteenth century may have accustomed us to the idea that technical accomplishment and emotional impact cannot go together, but the way we are ambushed by Baroque art makes a nonsense of that view.

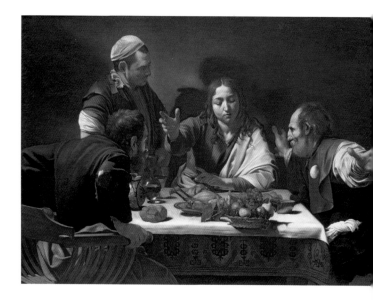

Caravaggio (1571–1610, *see* page 58) is a case in point. His great religious paintings come at spiritual life from a distinctly dark and menacing place, even as his secular works show the extent to which the influence of the Baroque 'trickled down' into artistic endeavour as a whole. Much of the impact of Caravaggio's works comes from their creator's skills in realistic representation: his ability to play tricks with light and sombre shadow. Caravaggio's influence is clearly apparent in the work of Artemisia Gentileschi (1593–1652) – the daughter of a friend of his – dazzling in its mastery, if often shockingly 'unfeminine' in its violence.

Flemish Baroque

The same extravagant energy and emotional immediacy are to be seen in the religious works of Peter Paul Rubens (1577–1640, *see* page 59). Again, though, the Baroque sensibility can be seen to have 'rubbed off' on his more secular creations. Bodies stretch and sprawl in extreme postures – and then, of course, there are those 'Rubenesque' women: celebrations both of 'real' femininity and the artist's skill in representing flesh. Anthony van Dyck (1599–1641, *see* page 61) painted religious works with much of the same bustling energy as Rubens, but it was with his portraits that he secured his lasting fame. These, though conspicuously calm in mood, show the distinctly Baroque ability to convert technical mastery into emotional immediacy.

Dutch Baroque

Boldness is key to the Baroque aesthetic: the portraits (often group portraits) for which Frans Hals (*c.* 1580–1666, *see* page 60) is remembered often seem dour and drab at first glance. The black garb of his Puritan subjects does not help, of course, though neither does Hals's loose and even sloppy-seeming brushwork. If observed for longer, though, they reveal the courage of a painter who had the confidence to be casual, to let himself go and to record the impressions of an instant: few have ever rivalled his ability to catch an expression, a moment or a mood.

Rembrandt van Rijn (1606–69, *see* page 62), a native of Leiden, is regarded as one of the greatest artists in the Western tradition. His great paintings – not just the narrative works but the landscapes too – are packed with drama. It is particularly in his portraits, however, that we find the miraculous technique of transmuting line and colour into feeling. Rembrandt's are some of the most irresistible representations of real men and women that we have. The great Dutch painters have a way of revealing the ordinary and everyday as in some sense sacred: nowhere is this more apparent than in the paintings of Delft-born Johannes Vermeer (1632–75, *see* page 66). His work is rightly revered for its use of light and for the astounding way it shows men and (more often) women in mundane situations completely transfigured by the fall of a sunbeam or the flicker of a lamp.

French Baroque

In France, too, artists were finding a painterly poetry in the natural scene: the landscapes of Claude Lorrain (1600–82, *see* page 63) speak to us with profound expressiveness even now. Nicolas Poussin (1594–1665, *see* page 64) brought a new aesthetic rigour and moral seriousness to landscape painting: he proved powerfully influential down into modern times.

Spanish Baroque

Light falls in a still more dramatic way in the work of Francisco de Zurbarán (1598–1644), investing saints and sacraments with a special grandeur. Like Caravaggio, the Spanish artist produced paintings of arresting and sometimes unsettling emotional impact by the way he counterpointed light and shadow. Seventeenth-century Spain was a major centre for Counter-Reformation values, and its painters could carry Baroque principles to extremes – sometimes so much so that (as was the case for El Greco earlier) their work teeters on the edge of absurdity. Zurbarán's skill is such that he can produce an air of sanctity in the humblest still life, finding a mystic beauty in a basket of fruit or a line of earthen jars.

Diego Velázquez (1599–1660, *see* page 65) was also capable of 'special effects' art when required, but for the most part he kept to the narrative

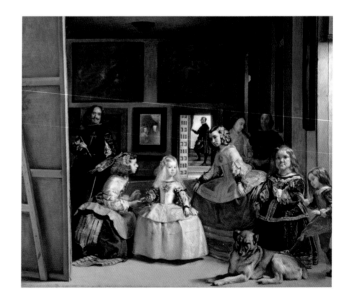

and portraiture, which are the court painter's stock-in-trade. He won his place among the very greatest artists of Western tradition thanks to the subtle flair and freshness with which he used line and colour, the understated sophistication of his composition and the perceptive honesty with which he caught the characters of those he portrayed.

The Baroque was a European trend, specifically rooted in the religious ferment of the seventeenth century, however secular some of its eventual expressions. Elsewhere in the world, the same conditions did not apply. In Qing-dynasty China, for example, Gong Xian (1618–89) was developing an aesthetic of restraint which specifically censured any displays of technical virtuosity. By contrast, Yun Shouping (1633–90) offered more suggestive parallels with his Western contemporaries: he popularized a markedly bold and colourful, confident and expressive style. The same might be said for Japan's Tawaraya Sotatsu (early seventeenth century) and his school.

Baroque Sends Itself Up

Some Baroque works, in their emotional intensity and technical bravura, went right through seriousness and out the other side. The danger of self-parody was always there. Increasingly, however, as time went on, Baroque values began to send themselves up: this tendency was apparent initially in the florid swirls and overexcited ornamentation of what became known as the 'Rococo'. Originally, this was a style of interior design whose decorative exuberance spilled across lines and angles to such an extent that the architectural structure seemed to melt away. But the word is also used to identify a recognizable strain in late-seventeenth-century and eighteenth-century art.

French Rococo

Rococo painting's first flowering was in France, where Jean-Antoine Watteau (1684–1721) set the fashion with his elegant studies of aristocratic festivities and leisure: he also drew on dance and comic theatre for his (resolutely upbeat) subject matter. But Watteau's work looked like searing realism next to the frankly frivolous court scenes of Jean-Honoré Fragonard (1732–1806) with their ever-present hints of private understandings and sexual intrigue.

Italian Rococo

Giovanni Battista Tiepolo (1696–1770) brought the Rococo style to Venice in all its extravagance. Critics who once deplored his 'lack' of depth now revelled in the festive energy of his crowded frescoes, the lovely play of light and the effortless abandon of his human forms. Giovanni Antonio Canal, or Canaletto (1697–1768), is not as insistently playful as many of his contemporaries were: he paints 'straight' landscapes in which human figures are incidental. But the jaw-dropping virtuosity with which he captures the effects of light is very much in the Rococo manner: the skies seem to glow in his famous scenes of his native Venice. Since so many of his paintings were bought by English art lovers, Canaletto moved to London for a time in the 1750s, capturing many of the city's landmarks in his Venetian style.

English Rococo

Canaletto's style was very different from that of his English contemporary, William Hogarth (1697–1764, *see* page 67), even though he, too, so often took London as his subject. In Hogarth's satirical paintings, however, people take centre stage: the streets are

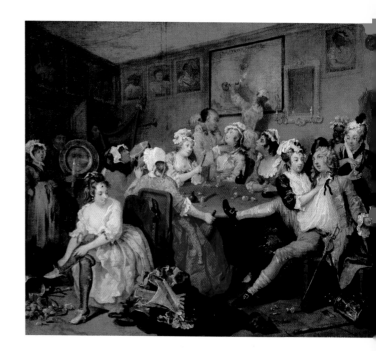

riotous assemblies of vice and crime, and the most elegant drawing room is a den of cynicism, hypocrisy and pretence.

English society received more respectful treatment in the work of Thomas Gainsborough (1727–88, *see* page 68); taken collectively, his portraits make up a 'who's who' of the country's upper class. However, the secret of his success was not flattery, as his patrons seem to have valued the sense they had that Gainsborough could respond to their human side, hinting at their whole characters, as complex as they were. Accomplished as his portraiture was, Gainsborough's first love was landscape: his engagement with nature is often evident in his work.

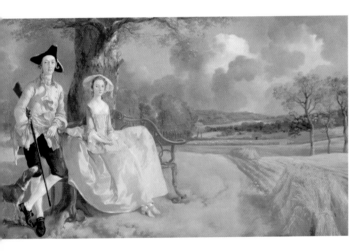

But both the landscape and the social order Gainsborough depicts were living on borrowed time. Innovations in science and technology had already started driving drastic change. They found an able artistic chronicler in Joseph Wright (1734–97, *see* page 70). Often known as 'Joseph Wright of Derby', his nickname is important: it was in the English North and Midlands that the 'Industrial Revolution' was taking form.

German Rococo

In Germany, the Rococo was largely confined to Catholic regions such as Bavaria. Here, though enthusiastically adopted, it was for the most part derivatively applied. Though considered attractive period pieces, such works have not endured as classics.

NEOCLASSICISM & ROMANTICISM ERA

Neoclassicism was an almost inevitable reaction to the frivolity of Rococo, and it was given a political dimension when it became the preferred style in France in the aftermath of the Revolution. A reaction to the sterile academic disciplines of Neoclassicism came towards the end of the eighteenth century with Romanticism, which began as a literary and philosophical movement and soon involved the fine arts. Individual aspirations, feelings, emotion and atmosphere were all emphasized, with the remote, the rugged and the exotic celebrated.

Neoclassicism

Ornamentation fatigue was setting in; in the Rococo, the Baroque had gone berserk and a little simplicity was overdue, it seemed. Where was the seriousness? The integrity? The sense of art as the authentic expression of its creator's feeling or conviction? Where was the inspiration in all these frills and folderols? In 1738, Charles III began building a palace for himself not far from Naples, newly conquered by his Spanish forces. As they dug away the earth to prepare a foundation, they hit upon an existing structure: a corner of an ancient city. Mount Vesuvius's eruption of AD 79 had buried Pompeii and its people beneath a blizzard of ash, fixing for ever an instant in Roman life – and of Roman art. In the months that followed, connoisseurs marvelled at the regularity and chastity they found in frescoes, mosaics, vases and amphorae – in just about everything they saw. The German art historian Johann Joachim Winckelmann (1717–68) was meanwhile promoting a new aesthetic of 'purity', founded in his understanding of ancient artefacts brought back from Greece.

There were other considerations too. In France, national life and culture seemed to have stalled, held back by the Bourbon monarchy, the aristocracy and the Church. A tide of discontent was rising inexorably. Searching for an alternative to this old order, writers and artists found inspiration in the annals of ancient Rome, looking beyond the imperial age to the days of the Republic. The people of

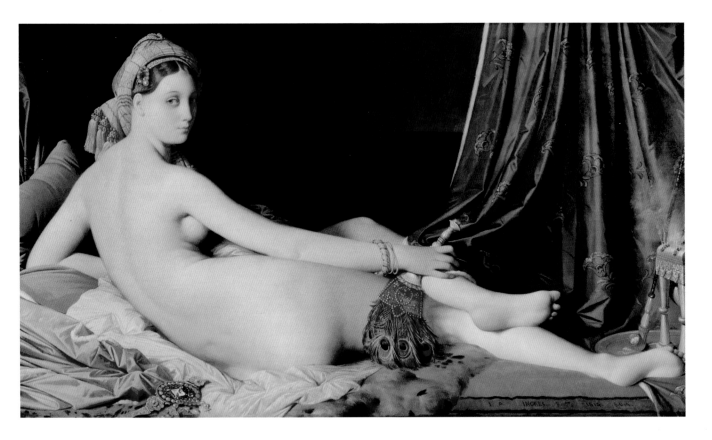

this heroic city had risen up in rebellion and driven out the tyrannous Tarquin kings. Painters such as Jacques-Louis David (1748–1825, *see* page 73) depicted stirring scenes of patriotic self-sacrifice. It was not just his subject matter, though: his manner of presenting it was a revolution in itself. Defiantly firm in outline and crisp in its contrast of light and shade, it could hardly have been more different from the frothy complexity of Rococo art.

When revolution came for real in 1789, this approach to art was to some extent institutionalized. The aesthetic endured as France, following in the steps of ancient Rome, made the transition from republic to empire in 1804, as Napoleon Bonaparte crowned himself Napoleon I. Jean-Auguste-Dominique Ingres (1780–1867, *see* page 78) created major works on epic Greek and Roman themes. But he also applied what he understood to be classical principles to modern subjects: his portraits in particular are remarkable for their clarity and classic poise. His works sum up the spirit of the age.

With eloquent advocates in Winckelmann and in the philosopher Gotthold Ephraim Lessing (1729–81), Neoclassicism caught the German imagination in no uncertain terms. Yet, of the hosts of artists who were enthused by these ideas, few produced any genuinely lasting work. Anton Raphael Mengs (1728–79) was one exception. The Swiss-Austrian Angelica Kauffmann (1741–1807) won widespread popularity. She painted portraits, and historical and mythological scenes in the neoclassical style.

In recent times, 'classicism' and 'Romanticism' have come to be seen as mutually exclusive opposites – the former balanced, regular, scrupulously policed in its proportions and carefully contrived (and even 'cold'); the latter warm and spontaneous, uncontainably emotional and 'free'. That is not how it seemed to artists at the time. Indeed, as we have seen, Neoclassicism was itself a reaction against artificiality in art, its great works composed as assaults on old and enslaving institutions and blows struck in the fight for liberty.

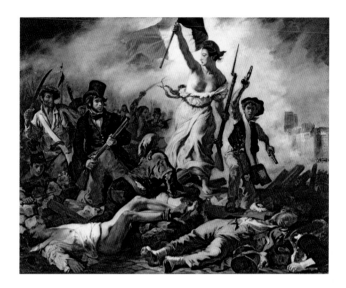

Romanticism in France

The career of the artist Anne-Louis Girodet de Roussy-Trioson (1767–1824) suggests that Romanticism was not a reaction to Neoclassicism, but a continuation of it. His composition is 'correct' in the classical manner, yet at the same time the sense of certainty is evidently breaking down, with outlines blurring and dreamy light effects. Wispy, misty backgrounds hint at unknown possibilities. Emotional engagement on the part of the viewer is not just invited, but demanded. The great works of Théodore Géricault (1791–1824, *see* page 80) are also consummately poised, with their statuesque figures arranged in the manner of ancient sculptures. The mood is utterly different, though, and the vision less straightforward: Géricault's paintings are powerfully unsettling and the undercurrents of passion – even violence – always felt.

It is in this victory of 'heart' over 'head' that the spirit of Romanticism might be said to lie, and it really arrives with the work of Eugène Delacroix (1798–1863, *see* page 82). Emotion – strong and turbulent – sets the tone, not just in his celebrated historical scenes, but even in his portraits. Delacroix's art was the result of careful study – into effects of colour in particular. But his paintings give the impression of having been dashed off in headlong haste in the throes of some creative fury.

By a terrible irony, France may be said to have played a part in a great Spanish artist's move towards Romanticism. Francisco de Goya (1746–

1828, *see* page 76) seemed a talented but unexceptional court painter under Charles IV. He was never quite as conventional as he may have appeared – many critics have felt they've detected a note of satire in his more apparently fawning portraits. Even so, they do nothing to prepare us for the dark and dreadful emotions unleashed in the work he did after the brutal French invasion of his country in 1808.

British Romanticism

In England, the excesses of the *ancien régime* in France had been avoided; so too were the tumults of revolution and the tumbrils of the Terror. But neoclassical theories of art had caught on here as well; they were most famously expounded in the *Discourses* of Sir Joshua Reynolds (1723–92, *see* page 71), who was distinguished not only as a painter but also as a professor (indeed, as co-founder of the Royal Academy of Art). The artist's aim, he insisted, was not to reproduce the particular detail but to 'reduce the idea of beauty to general principles'. When painted by him, a woman would be idealized, her finer features developed, so that the final study would show her as in some sense the epitome of womanhood. (Not surprisingly, Reynolds' portraits were in great demand.)

Other important painters in what was to be something of a golden age of English portraiture can be seen as broadly conforming to Reynolds' rules. George Romney (1734–1802) seems 'Reynoldsian'

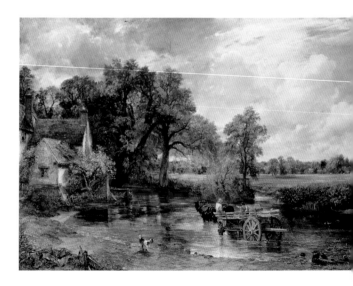

in his approach, despite Reynolds' clear loathing of the younger artist, born perhaps of envy of the most fashionable society portraitist of the age. Sir Thomas Lawrence (1769–1830) was an idealizer too, though it has been argued that his clear delight in his subjects' quirks of appearance and idiosyncrasies of manner looks forward to the values of the Romantic age.

There is idiosyncrasy to the nth degree in the work of Henry Fuseli (1741–1825, *see* page 72): no one better exemplifies the growing interest in that nightmarish reality believed to lie at Reason's heart. Rationalism was still being promoted, though – in Edinburgh especially, where the 'Scottish Enlightenment' was in full swing, thanks to thinkers like David Hume and Adam Smith. Sir Henry Raeburn (1756–1823, *see* page 75) captured the artistic spirit of this time.

It is not clear how conscious Reynolds ever was of the fact that he was hated as the great anti-artist by William Blake (1757–1827, *see* page 74), despite the fact that the London-born autodidact had enrolled himself in one of Reynolds' classes at the Royal Academy for a while. In opposition to Reynolds, Blake argued for an aesthetic of infinite particularity and for a mystic power of perception which would be able, in his words, to 'see a world in a grain of sand'. His own art, outrageously original, was too offbeat to have significant influence: he remains a one-off in the English artistic tradition. But his rebellion against Reynolds' idealizing art and his belief that the artist should find the universal in the quirky detail were to be key to the developing sensibility of Romanticism, in literature as in art.

In the English context, the Romantic movement was led by poets – among them two friends: William Wordsworth (1770–1850) and Samuel Taylor Coleridge (1772–1834). They had little obviously in common with Blake, but shared his sense that general principles could only be apprehended by the individual mind, and by its contemplation of nature – whether human nature or the natural world – in its tiniest details. Hence, their 'discovery' of England's Lake District – dismissed as a barren waste by earlier generations of writers – and the sense of uplift they felt in the countryside.

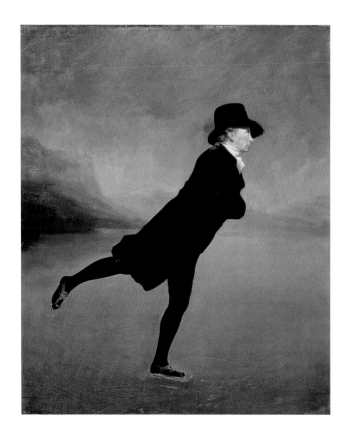

John Constable (1776–1837, *see* page 81) did for painting something of what Wordsworth had done for poetry. Earlier artists had evidently enjoyed nature, but in their works, flowers, trees, animals and landscapes had by and large been allegorical figures: symbols of mythic or religious ideas – virtues and vices, sacraments and mysteries. This had been true to some extent even for the most obviously 'poetic' of eighteenth-century landscape painters. Even John Robert Cozens (1752–97) had responded to the natural scene only in so far as it seemed to him to be intrinsically 'picturesque'. For Constable, however, the countryside was significant in and for itself. If his Suffolk scenes were symbolic, it was only of an overarching order: what Wordsworth called the 'wisdom and spirit of the universe'.

Norwich School

Communications in rural England were still poor at this time and so, despite his being almost a neighbour of Constable's in East Anglia, it

is not clear whether John Crome (1768–1821) ever saw his work. Or, for that matter, whether he was familiar with Wordsworth's verse. No matter: Crome, the son of a Norwich weaver, was still very much a man of his time – a time in which the Romantic philosophy of life and nature was 'in the air'. Crome certainly responded to nature in the most profound and immediate way, as did his followers in what became known as the 'Norwich School'. John Sell Cotman (1782–1842) is today the most famous of these.

Alone among this Norfolk group, Cotman won a degree of national recognition in his own lifetime – partly through the patronage of fellow painter Thomas Girtin (1775–1802). Another Romantic landscape specialist, Girtin is particularly celebrated for his work in watercolours; his work in this medium established what was to be an enduring tradition in English art. He was driven to extend himself by his friendly rivalry with J.M.W. Turner (1775–1851, *see* page 83); a one-sided struggle, posterity has for the most part judged. Not because Girtin was a poor painter – anything but. Turner, however, was the artistic phenomenon of his age. There was nothing pastoral or peaceful about his great (and controversial) landscapes: land, sea and sky clashed explosively here in some of the most dynamic paintings ever seen.

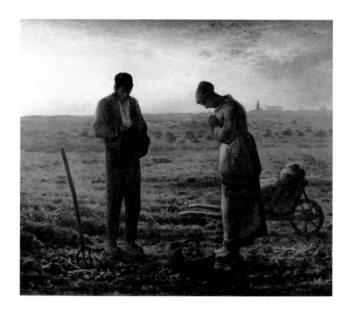

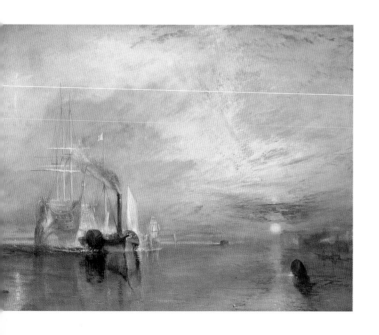

Romanticism in Germany

Poets such as Johann Wolfgang von Goethe (1749–1832) and Friedrich Schiller (1759–1805) had brought Romanticism to Germany. Not the peaceful harmony-with-nature Romanticism of Wordsworth, but a wilder philosophy of Sturm und Drang, or 'storm and stress'. The landscapes of Caspar David Friedrich (1774–1840, *see* page 79) epitomize this approach in artistic terms: human figures stand alone while lightning plays or tempests swirl.

Hudson River School

Constable and Turner made a big impression across the Atlantic. Here too, thinkers such as Ralph Waldo Emerson (1803–82) and Henry David Thoreau (1817–62) were putting forward the Romantic view that the individual could best find himself or herself in the vastness of the American outdoors. In the autumn of 1825, Thomas Cole (1801–48) made his first trip by steamboat up the Hudson from New York City. He was spellbound by the symphony of reds, yellows, oranges and browns he saw on this voyage of artistic discovery. Inspired, he gathered a group of followers around him, including Frederic Edwin Church (1826–1900) and the African-American artist Robert Scott Duncanson (1821–72). Collectively, these have become known as the 'Hudson River School'.

IMPRESSIONISM & POST-IMPRESSIONISM ERA

In its heyday, between the late 1860s and about 1879, Impressionism was a remarkable revolution against classicism, seeking to achieve immediacy and spontaneity, playing on the emotions as much as the imagination to achieve results. On the fringe of Impressionism was Paul Cézanne, who felt uneasy at the lack of discipline in this style and wished to return to a greater reliance on form and content without sacrificing the feeling for light and brilliant colours. Out of this evolved Post-Impressionism, a term that originally meant merely 'after Impressionism', but which became the springboard to all the varied 'isms' that came under the heading of modern painting.

Realism

For the Romantics, the beauty of nature in the small scale was a way of seeing the wonder of the overall order – Blake's grain of sand, or Wordsworth's daffodils. It made sense, then, for a 'provincial' talent like that of Constable to exert an international influence with his emphatically local scenes. He certainly had his emulators in France: one group, known as the 'Barbizon School', for the village in Seine-et-Marne where they set up, included such painters as Jean-Baptiste-Camille Corot (1796–1875), Théodore Rousseau (1812–67) and Jean-François Millet (1814–75, *see* page 88).

Millet, in particular, believed that human figures should be included in his scenes – objectively, though, as features of the landscape, rather than as dramatic actors. Along with Millet, Gustave Courbet (1819–77, *see* page 86) and Honoré Daumier (1808–79) led the march towards 'Realism'. Flying in the face of the age-old assumption that the business of art was to be 'beautiful' in some absolute sense, it called for the depiction of nature, not as it somehow 'should' be, but as it was. Both Daumier and Courbet were convinced that art had a duty to show society to itself, bringing the sufferings of the poor and the oppressed to the attention of an indifferent France.

Pre-Raphaelite Brotherhood

As his name suggests, the English poet and painter Dante Gabriel Rossetti (1828–82, *see* page 94) had Italian roots. He took a lifelong interest in the art and culture of his father's homeland – and was drawn

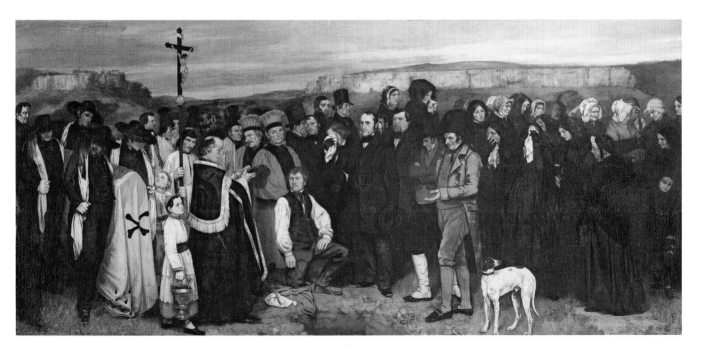

especially to the works of the medieval period. He was not alone in this. Though Romanticism could be seen to have developed out of Neoclassicism, these origins had been forgotten over time. By the early nineteenth century, there had been a wholesale reaction against the symmetry and regularity of the classical ideal. Long despised for their roughness and barbarity, the Middle Ages now seemed wild and authentic in an exciting way. Since the rot had set in with the Renaissance, Rossetti, with friends like William Holman Hunt (1827–1910), harked back to an earlier – and apparently simpler – time, before Raphael and his followers had introduced a more sophisticated style. Hence the foundation, in 1848, of the 'Pre-Raphaelite Brotherhood', whose style was also embraced by artists such as Ford Madox Brown (1821–93, *see* page 87).

The Pre-Raphaelites were, of course, extremely sophisticated themselves, and – in their own way – utterly modern. The dreamy damozels of Rossetti, Hunt and younger disciples such as Edward Burne-Jones (1833–98) may glow with all the luminosity of Giotto's virgins, but they are unmistakeably Romantic creations for all that. Pre-Raphaelitism can be seen as part of a wider craze for 'medievalism'; this seems to have been a reaction to the Industrial Revolution that had swept Britain. The movement took in everything from poetry to architecture – even furniture-making and interior design. With his Arts and Crafts movement, the socialist poet and artist William Morris (1834–96) sought a way of preserving artisanal skills and values in an age when, increasingly, everything was factory-made and mass-produced.

An artist loosely associated with the Pre-Raphaelites but who is in fact an example of the sumptuous late-Victorian style of Aestheticism, is Sir Frederic Leighton (1830–96) – his classically inspired, dreamlike *Flaming June* of *c.* 1895 (*see* the cover of this book) being his most well-known piece.

Impressionism

The word 'Impressionism' was a contemptuous coinage, given to the world in 1872 by a critic who had just seen a picture of Le Havre by

Claude Monet (1840–1926, *see* page 100). Entitled *Impression, Sunrise,* it seemed to its scathing reviewer no more than a vaguely directed splurge of colour. That view is still widely held. Even though Monet's painting is generally acknowledged to have been a breakthrough work of modern art, it is often assumed to be an anarchic daubing – albeit an extraordinarily exciting one.

However, Monet could hardly have been more rigorous in his approach to art. His move towards 'Impressionism' was driven by a desire for greater realism. Through the 1860s, he and his friends Pierre-Auguste Renoir (1841–1919, *see* page 91) and Alfred Sisley (1839–99, a Frenchman with British parents) had discussed the best ways of recording nature as the eye perceived it. They met in the Café Guerbois, a bohemian haunt on Paris's Avenue de Clichy, where they were joined by the Realist writer Émile Zola (1840–1902) and others in a circle presided over by Édouard Manet (1832–83, *see* page 93). All shared an attitude to art that set the recording of reality above such things as composition or surface finish, even though they differed in other things. Zola's fiction, unsparing in its portrayal of the life of the impoverished underclass, used language with astonishing meticulousness to capture the sense of squalor; Manet used sketch-like brushstrokes to dab out arrestingly vivid scenes of high society.

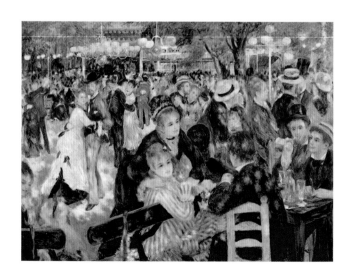

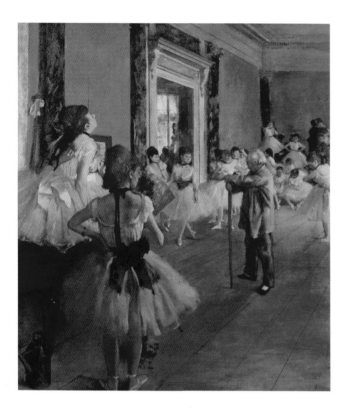

Monet, Sisley and Renoir were all but scientific in their approach. At a time when fast-improving photographic technology was prompting thought on how we 'saw' the world around us, painters pondered the implications for their art. They were potentially far-reaching. The certainty was growing that impressions of light were received and ordered by the human brain. Were outlines, and even 'form', nothing more than conventions? Paradoxically, the three friends were working strenuously to achieve passivity: to make themselves mere receptors – rather than organizers and articulators – of light impressions. Those impressions changed by the moment, they could see, with every movement of a cloud, every stirring of the breeze and every ripple of the water. It was no use hoping to capture a scene by making preliminary sketches and then taking them back to the studio to be worked up into a finished landscape. In pursuit of perfect authenticity, the friends liked to paint *en plein air* – in the open air – working in the utmost haste and in the immediate presence of the scenes they were depicting. Sisley devoted his whole career to the attempt to catch the Impressionist moment, confining himself to landscape painting.

Renoir was more pragmatic – and more interested in people, perhaps. Seeing that the way the light caught a dress or umbrella was as distinct and momentary as any glinting puddle or trembling leaf, he brought Impressionist techniques to paintings of elegant women, children and bustling crowds. In this regard, he can be seen to have more in common with Manet, a late recruit to the movement, or with Edgar Degas (1834–1917, *see* page 90). Publicly dismissive of Monet *et al.*'s project, Degas insisted that he remained a Realist; rather than landscapes, he painted human subjects: dancers and down-and-outs. Despite his protestations, however, much about his technique and his treatment of light and colour are clearly in harmony with the new aesthetic, and he has generally been included among the Impressionists since.

American artists were quick to respond to the artistic revolution in France, and James Abbott McNeill Whistler (1834–1903, *see* page 89) was perhaps the first to do so. Based in Europe, moving between London and Paris, Whistler was on the spot in those crucial years when Realism was giving way to Impressionism. At the same time, he maintained a certain detachment from these developments. Whistler created his paintings by piling on layer after layer of colour until he had the effect he wanted – he never strove for the sort of light-and-shade snapshot effect the orthodox Impressionists were seeking. The overall result is strikingly similar, though.

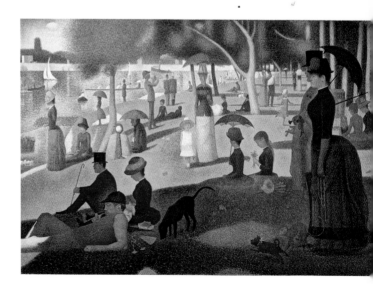

Post-Impressionism & Pointillism

The title 'Post-Impressionist' might in theory mean no more than whatever came after Impressionism. In practice, it is a little more precise. Even though it might not have been so much a 'movement' as a 'tendency', clear preoccupations and priorities can be identified among those artists who are generally labelled in this way. One was a mounting impatience with the way 'official' Impressionism had subordinated so much to what now seemed like scientific theory and technique. Why invest so much effort and artistic talent in the attempt to apprehend the way in which – just for that one passing moment – sunlight played on a lawn or lily pond?

These things are cyclical: it is easy to see why it should have mattered so much to Monet and his friends, reacting as they were to the convention-bound compositions of the academic painters. To arrest the reality of an instant – what higher artistic aspiration could there be than that? But there was no getting around the fact that, by their very nature, Impressionist paintings seemed provisional – so much slighter than the monumental masterworks of the past. The feeling was growing, too, that it was not enough for an artist to be a passive recorder of impressions: should a painting not have some expressive purpose?

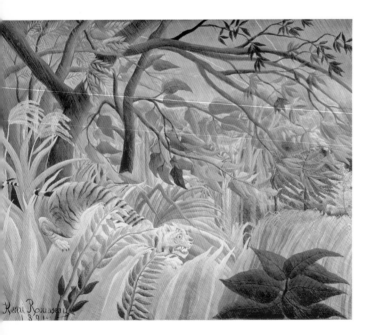

Some of those involved had served their time as signed-up members of the Impressionist movement. Camille Pissarro (1830–1903, *see* page 92) was one example. Born in the West Indies, he had been schooled in France and, discovering a desire to be an artist as a young clerk, had steeped himself in the Realist values of Courbet and Corot. When Impressionism was born, he was bowled over by the impact of younger contemporaries such as Monet and Renoir, and quickly became a convert to the cause. Yet Pissarro outlived this enthusiasm, eventually coming to feel that he had exhausted Impressionism's possibilities.

Pissarro's version of Post-Impressionism was a curious mix of back-to-Realism subject matter (peasants bringing in the harvest, scenes of city life, etc.) and an Impressionist only-more-so technique called 'pointillism': the use of points or dots of different colours to build up pictures, rather like the pixillated images of today. Sometimes referred to as 'Neo-Impressionism', this system, scientifically worked out by another Post-Impressionist painter, Georges Seurat (1859–91, *see* page 95), produced some wonderfully memorable works, though artistically it was to prove a cul-de-sac.

Cézanne, Rousseau and Van Gogh

For a time in the 1860s, Pissarro's student, Paul Cézanne (1839–1906, *see* page 99), was another Impressionist who eventually wearied of the style. He grew disillusioned by the slightness to which he felt Impressionist art was condemned by its concern to capture the moment: the slapdash sketchiness dictated by the need for haste. The basis of his technique, with its short brushstrokes, was not a million miles from that of the Impressionists, but he was much more compositionally minded than they had been. Piecing together pictures by building up boldly coloured blocks and planes, and other geometrical shapes, Cézanne could be said to have rediscovered form.

The 'naïve' style of Henri Rousseau (1844–1910, *see* page 97) took Post-Impressionism in another direction entirely. Inevitably, perhaps, Rousseau was underestimated in his own time, and his childlike fantasies derided or disdained as kitsch. Only gradually, as the generations have gone by and we have come no nearer to fathoming their mysteries, has it become clear that this is a painter for all time.

Pretty much the archetypal 'tortured genius', the Dutch painter Vincent van Gogh (1853–90, *see* page 96) had so many emotions surging in that head of his that he could never have been content passively recording reality in the Impressionist way. Yet his work is unthinkable without the Impressionist precedent and he adopted and adapted Neo-Impressionist techniques, accumulating dots or longer strokes in a manner that is reminiscent of the Pointillists. But Van Gogh was nothing if not an expressive artist. Despite the mythology that has built up around him, however, he was by no means always violently or tragically expressive in his paintings, though his darker works do have a unique grandeur.

Art Nouveau

Though primarily an architectural and a decorative style, Art Nouveau ('new art') did nonetheless have a recognizable impact in the *fin de siècle* fine arts world. Both the Czech painter Alphonse Mucha (1860–1939) and the English illustrator Aubrey Beardsley (1872–98) produced enduringly important works, with the latter's drawings strongly influenced by the Japanese woodcuts which were then in vogue. The Austrian artist Gustav Klimt (1862–1918, *see* page 102) occupies an ambiguous position, poised between the festive cheer of Art Nouveau and the more portentous styles of the Symbolists.

Symbolism

The 1880s saw a radical pendulum swing against realism in art – though in poetry, at least, the reaction had started some years before. Since Charles Baudelaire (1821–67) outraged the proprieties with his collection *Les Fleurs du Mal (The Flowers of Evil)* in 1857, poets such as Stéphane Mallarmé (1842–98) and Paul Verlaine (1844–96) had pushed the boundaries even further. Creating a quasi-mythology of animal and other symbols to represent big and powerful ideas such as love, death and decadence, they had dispensed with the imperative to describe the real world. Painting, which had reacted to Realist values by trying to push them even further in Impressionism and Post-Impressionism, was slow in catching up with the new trend. Then, in 1886, the Greek-born poet and critic Jean Moréas (1856–1910) published his profoundly

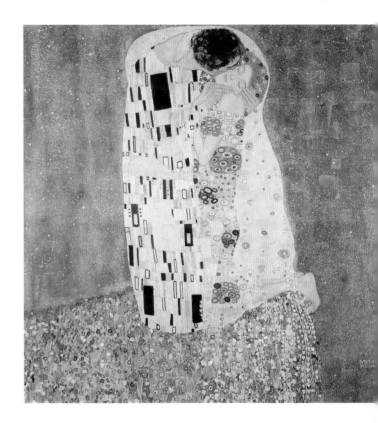

influential *Symbolist Manifesto*. Art, it announced, was not to represent scenes, actions, animals or people for their own sake – only for their 'esoteric affinities with primordial ideas'.

Gustave Moreau (1826–98) was one who heeded the call. He used biblical figures to sometimes decadent ends, and raided the classical legends for scenes of cruelty and rape. Indeed, 'primordial ideas', in the Symbolist code, were just about always dark and dangerous: no one was interested in the thought of everlasting good. The nearest anyone got was the eerily ambiguous work of French painter-printmaker Odilon Redon (1840–1916). Feeling that Europe had no more to offer, Paul Gauguin (1848–1903, *see* page 101) set out for the South Pacific: its inhabitants, strange and exotic (from his point of view, at least), appear as mythic symbols in his works. If the ethics of this approach seem questionable in these post-colonial times, the vibrant colour of Gauguin's works is not in doubt. The work of the Norwegian Symbolist painter Edvard Munch (1863–1944, *see* page 98) is just as bright and bold, but more starkly unsettling.

MODERN ERA

As the twentieth century gathered pace, so society began to change ever more quickly. New art styles and movements appeared and disappeared equally rapidly. Boldness and self-confidence were the keys to the artistic revolutions of the early twentieth century: the colourful abandon of the Fauvists, the staggering boldness of Cubism, the absurdity of Dada, the simplicity of De Stijl. Understanding modern art, if it can or is meant to be understood, is not just about reading its history or precedents, but more about engaging with an ethos.

Fauvism

The conviction was growing among artists that, however accomplished they became in the existing conventions, they would be no nearer to capturing the essential nature of their world. Why mirror back to the viewer a vision of what he or she already knew? And besides, some felt, the world was not about what we could see or touch 'out there' – what of the emotions 'in here' which did so much to govern our perceptions?

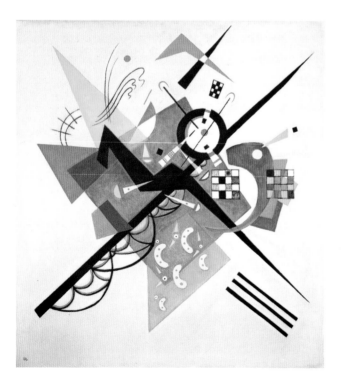

Among the first to rebel against the old ways was Henri Matisse (1869–1954); while he kept the representational rules of proportion and perspective (more or less), he went crazy with his use of colour. The subject of the painting was the artist's creative endeavour, he believed: boldness and expressiveness were more important than truth to (some slavishly objective view of) life. André Derain (1880–1954), Raoul Dufy (1877–1953, *see* page 112) and Maurice de Vlaminck (1876–1958) adopted his approach with enthusiasm. Those who saw the group's work at the 1905 *Salon d'Automne* in Paris were shocked – but more modern-minded visitors were excited too. As with the Impressionists, a critic's sneer bestowed a title on the movement: they were not artists, one reviewer wrote, but Fauves – wild beasts.

Expressionism

Comparable developments were afoot in Germany, where a generation of exciting new artists was coming through. In 1905, Ernst Ludwig Kirchner (1880–1938) had launched his *Die Brücke* ('The Bridge') school in Dresden. 'What is great about man is that he is a bridge and not a goal,' the German philosopher Friedrich Nietzsche (1844–1900) had said. Kirchner saw it as his generation's duty to bridge the gap between an exhausted past and a dynamic future. Erich Heckel (1883–1970) was among his famous followers.

In Munich, Russian-born Wassily Kandinsky (1866–1944, *see* page 108) was also creating memorable art in an Expressionist vein. His painting *Der Blaue Reiter (The Blue Rider)* gave its name to a group of followers, including Franz Marc (1880–1916) and Paul Klee (1879–1940, *see* page 110). *Der Blaue Reiter* principles were articulated most memorably by member August Macke (1887–1914): 'The senses are our bridge between the incomprehensible and the comprehensible,' he wrote. 'Forms are powerful expressions of powerful life,' or at least they should be. Instead, he believed, the forms of art had become detached from the deep emotions they should express. There could be no clearer proof of this, said Macke, than the banishment of 'primitive' art to the museum. Really, so-called 'savages' were Europeans' superiors: more closely in touch with the elemental qualities of life.

Meanwhile, the US painter Edward Hopper (1882–1967, *see* page 111) shows no sign of such 'primitivist' tendencies – yet his works betray a deep discontent with modern 'civilization' and the unbearable isolation of the individual in society.

École de Paris

Art does not come much more elemental than the dead-meat still lifes of Chaim Soutine (1893–1943). The Belarusian Jew was part of a group of immigrants in pre-war Paris now known collectively as the *École de Paris* – though they were a social community rather than an artistic 'school'. Soutine's uninhibitedly Expressionistic works have little in common with the emaciated elegance of the portraits painted by his Italian friend Amedeo Modigliani (1884–1920, *see* page 106).

Cubism

If some had seen strange new forms as ways of communicating hitherto unacknowledged emotions, others sought new forms simply because the old ones misrepresented reality. Perspective was a problem. It had been a liberation for Renaissance artists, but was it now imprisoning painters, restricting them to a single representational plane?

Georges Braque (1882–1963, *see* page 105), a former Fauve, grew away from the group's Expressionist values. More important than what he felt, he reasoned, was the way he represented what he saw. The world was not two-dimensional, so why depict it as though it were? Braque was increasingly drawn to ideas of geometrical formation and multiple perspective – seeing objects from a number of angles at once. Ironically, given his desire to see things 'in the round', he found a model for development in Cézanne's square, geometrical building-block style.

'Cubism', as it developed in the years before the First World War, can be seen as either a rejection or a development of the Impressionist project, or even, it could conceivably be argued, both. Where Monet and Sisley had sought to arrest the perceptions of the moment, recording the fall of light and shade we saw, the Cubists set out to break up what could only be a two-dimensional mock-up of a reality that had three dimensions. Juan Gris (1887–1927) rallied enthusiastically to the Cubist cause.

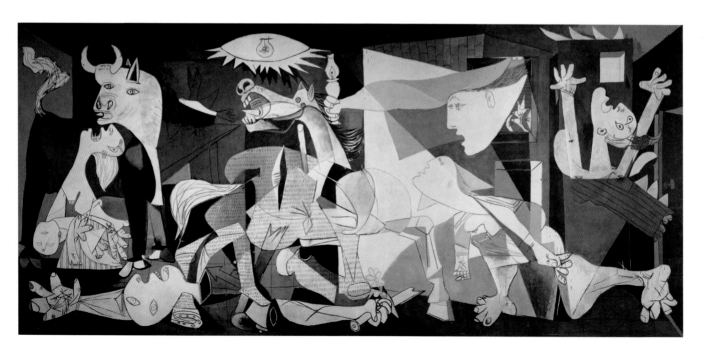

Braque's fellow Spaniard Pablo Picasso (1881–1973, *see* page 116) had already attempted to tackle the problem of perspective from various viewpoints. For a time, he had experimented with Primitivism. Like Macke, he had been moved by what he had seen of 'savage' art. For him, though, it represented the possibility of different (cultural) perspectives. Picasso pursued his interest in perspective into the formal area of Cubism, creating some of the undisputed masterworks of modern art.

Purism

One important critique of Cubism came from a pair of friends: Amédée Ozenfant (1886–1966) and Charles-Édouard Jeanneret (1887–1965), better known by his pseudonym of Le Corbusier. As might be expected of the future founder of the 'International Style' in architecture, Le Corbusier loved the three-dimensional aspirations of the new art but disliked the fuss and clutter of even the most rigorously orthodox Cubist canvases. The man who was to insist that buildings were 'machines for living' liked to think of paintings as mechanisms as well: ratios and balances between geometric areas of colour were more important than such 'painterly' qualities as tone or texture. In keeping with this belief, Ozenfant's works are strikingly cool and poised. Fernand Léger (1881–1955, *see* page 119) could be said to have straddled Cubism and Purism.

Futurism

Many of these experimental aesthetics have an eccentric air in retrospect, but – knowing what we now know – Futurism seems positively pernicious. It was first proposed by the Italian poet Filippo

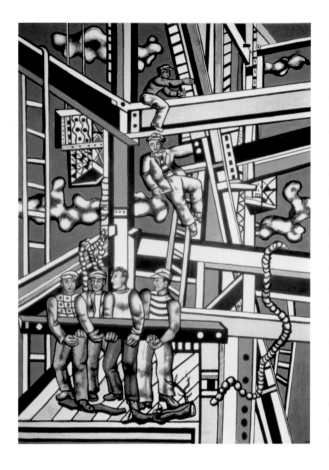

Tommaso Marinetti (1876–1944), who published his 'Manifesto of Futurism' in 1909. As its name suggests, it exalted the future – but at the expense of a past whose fabric and values had to be ruthlessly destroyed. A roaring aero engine was more beautiful than any old oil painting; no ancient sculpture could be as sublime as the explosion of a modern bomb. 'We will glorify war – the only true hygiene of the world … We will destroy museums and libraries, and fight against moralism, feminism and all utilitarian cowardice,' read the Manifesto. Marinetti was to have his way – and not just in the world of art: a decade later, Benito Mussolini (1883–1945) was to found his Fascist Party. Two decades after that, the Axis plunged the world into war and Hitler introduced the hideous 'hygiene' of his Final Solution.

It is hard to view the Futurists other than through the filter of such events, but they did produce enduring creative works. Marinetti's longing for an art which 'no longer satisfied with form and colour' and sought to catch 'the dynamic sensation itself' seems perfectly respectable – and is exemplified in the energy and élan of canvases by Carlo Carrà (1881–1966) and Giacomo Balla (1871–1958).

Suprematism

The Ukrainian painter Kasimir Malevich (1879–1935) believed that modern painting had to get back to basics and that the way lay more through maths than 'art' – at least as traditionally conceived. He came up with the idea that geometry was to the visual arts what grammar was to language. Every artistic expression, he maintained, was underpinned by two fundamental forms, the square and the circle.

Constructivism

In 1914, Vladimir Tatlin (1885–1953) gave Cubism a Communist
twist. The Russian radical was inspired in part by Picasso's
experiments in three-dimensionality. By this time the Spanish master
was semi-sculpting bits of string and cardboard into his works. This
technique resonated with a Russia on the brink of a workers'
revolution. Left-wing artists could exalt the cause of labour by using
bits of steel and concrete in their work. If Constructivism has
generally been a matter more of historical than enduring artistic
interest, an exception has to be made for the witty and graceful
works of El Lissitzky (1890–1941). These make enjoyable and
intriguing viewing to this day.

Vorticism

A writer as well as an artist, Percy Wyndham Lewis (1882–1957) can
be seen as offering an English equivalent of Futurism – with all the
cultural differences that this entails. 'At the heart of the whirlpool,'
he explained in 1914, 'is a great silent place where all the energy is
concentrated. And there ... is the Vorticist.' It is only fitting that a
fellow countryman of Wordsworth would have used a natural image,
that of the whirlpool in a stream, and yet Wyndham Lewis's vortex
clearly plays the part that the roaring turbine would have played for
Marinetti and his friends.

De Stijl

Meanwhile, in the Netherlands, Piet Mondrian (1872–1944, *see* page
113) had been laying down the founding philosophy of De Stijl (the
name simply means 'the style' in Dutch). One of the great paradoxes of
the De Stijl style is that it looks so unquestionably rational (all bold,
bright colours and clean shapes, geometrically arranged) and yet it
arose directly out of Mondrian's mystic quest for enlightenment. He
pursued this through some of the various spiritualist theories which
were fashionable then. It was in the belief that art had to concern itself
with essential truths rather than accidental details that Mondrian
shunned not just the representational but also the painterly – any
obvious mark of texture or technique. Pure and simple as they are,

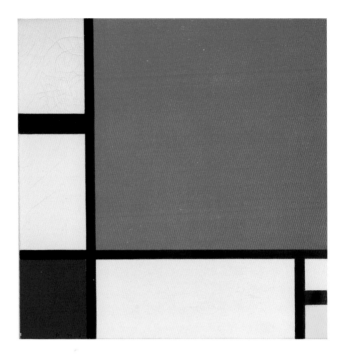

Mondrian's collections of lines and squares are intended to draw us on
to some transcendental level, beyond art.

Bauhaus

The Bauhaus was founded by Walter Gropius (1883–1969) in Weimar,
Germany, in 1919 and, while its primary impact was on architecture, this
institution should not be ignored. Bauhaus (the literal meaning of the
name is 'house of building') offered a complete new approach to
construction and design, combining form and function. Nothing could be
beautiful that was not useful and well made. Like Morris's Arts and Crafts
movement, it exalted the role of the artisan. No one painter personified
the Bauhaus approach to art, but it exerted a strong and influential
gravitational pull on the painting of the 1920s. Kandinsky, Klee and
Mondrian (among many others) spent periods as professors there; while
doing their bit to modify the Bauhaus culture, the Bauhaus affected them.

Dada & Surrealism

In the same way as the Cubists had rebelled against the rules of
perspective and the Expressionists against the duty to depict an objective
reality, a new generation began to take a stand against all reason. Why

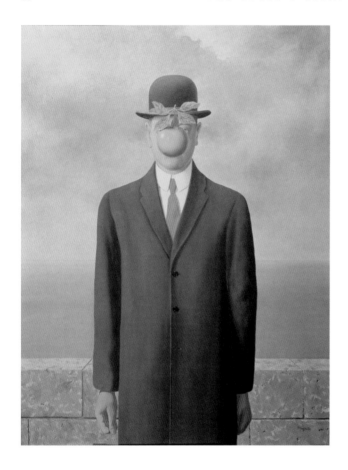

great art. His meditations on his people's myths opened up a wonderful world of form and colour – and anticipated the dreamlike visions of the Surrealists. Another who took his own artistic route to a quasi-surrealist strangeness was the Italian painter Giorgio de Chirico (1888–1978, *see* page 107). His concern to represent a 'metaphysical' reality – 'that which can't be seen' – clearly anticipates the great experiment on which the Surrealists were to embark just a few years later.

Strange and wonderful as the Surrealist vision is, it is easy to assume that it, too, is governed by a random anarchy. But nothing could be further from the truth. As with Impressionism, what seemed a 'crazy' mess was carefully disciplined; Surrealism had scientific pretensions indeed. The theory did not actually originate in painting: it was the brainchild of poet and critic André Breton (1896–1966), who published his *Surrealist Manifesto* in 1924 and quickly assembled a group of literary and artistic disciples around him. The Surrealists believed they were pursuing a rigorously formulated 'psychic automatism', unpacking the subconscious after the fashion of psychoanalyst Sigmund Freud (1856–1939).

In its way, Surrealism was staggeringly literal-minded; it is striking now how accomplished painters like René Magritte (1898–1967, *see* page 124) or Salvador Dalí (1904–89, *see* page 114) were in the skills of old-fashioned representational Realism, wildly improbable as

be slaves to 'sense' when a deeper truth was likely to be found in our unruliest impulses – or even in absurdity itself?

To the artists and intellectuals sitting out the First World War in Zurich, it was only too clear that the world was crazy and that only nonsense could make any kind of sense. 'Dada' was accordingly an anti-art; the movement's name was manifest gobbledegook, as were the poems and plays – or random doodlings – of French-Romanian founder and member Tristan Tzara (1896–1963). Artists such as Kurt Schwitters (1887–1948), Hans Richter (1888–1976), Max Ernst (1891–1976) and former Cubist Marcel Duchamp (1887–1968, *see* page 104) all made their contributions.

Born a world away from artistic Paris, a product of Tsarist Russia's Jewish *shtetl*, Marc Chagall (1887–1985, *see* page 103) found a way to turn profound provincialism into modish metropolitanism – and

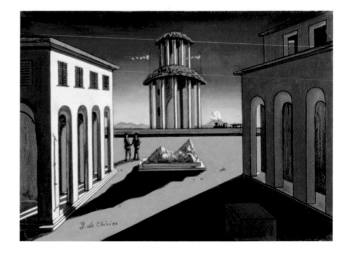

their arrangements of its objects are. The latter's stock has fallen of late, but it is impossible to regret the rise to prominence of his fellow Catalan Joan Miró (1893–1983, *see* page 109): 'the most Surrealist of us all', in Breton's words.

Breton's boys were very much a male clique: it doesn't seem to have occurred to the Surrealists that the sexuality their work was saturated with might not be universal; that femininity might be more than a force for psychic turbulence, for primeval desires and fears. Or, for that matter, that the non-European and non-North American world might have a civilization of its own; that it might exist not only as a frightening 'Other' but in its own right. It is for both these reasons – and the sheer extravagance of her gifts – that the Mexican artist Frida Kahlo (1907–54, *see* page 115) is so important.

Abstract Expressionism

After 1939, the centre of artistic power moved away from a Europe devastated by war; the United States was to take the lead – not just economically but also creatively. True, many of the participants in this transatlantic renaissance were refugees, but they were in no doubt that they were producing 'American' art. It was art of a very different sort than had been seen before. However outlandish an Expressionist painting was, it was still a painting of something – a blue rider, a bridge, a dancing couple or a nude. For centuries it had gone without saying that a painting had to be a picture – yet Expressionism had opened the way to another approach. Its subject was not the thing that the painter saw, but the emotion with which he or she set it down. Why, in that case, did there have to be a 'thing' at all? There was *some* precedent for abstraction in art. Kandinsky's 'non-objective' works of 1913 had shown what could be done. In the years after the Second World War, however, a new generation of artists took up where he had left off: Abstract Expressionism was the way to go.

Armenian refugee Arshile Gorky (1904–48) was a pioneer. He had worked in the Post-Impressionist and Surrealist styles in the pre-war period before finally, in the early 1940s, hitting on a powerfully emotional abstract approach. Friends such as Willem de Kooning

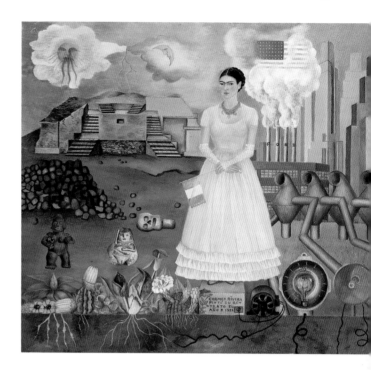

(1904–97, *see* page 118) were bowled over by his work, and inspired to emulate it. To younger contemporaries such as Jackson Pollock (1912–56, *see* page 120), de Kooning introduced a new kind of Action painting: paintings created through the accumulation of random strokes and splashes. Again, there was method in the modernist madness: like the Surrealists with their 'automatism', the Action painters hoped that, in bypassing their conscious creativity, they would open up a window on their subconscious minds.

In the 1950s, Mark Rothko (1903–70, *see* page 122) and Hans Hofmann (1880–1966) led a younger group away from the splashes, dashes, dabs and dribbles of the Action painters. They created cleaner-looking abstracts based on large 'fields' of blank, unbroken colour. These would be arranged concentrically or distributed about the canvas, overlapping in places. Key to the curious power of such 'Colour Field' paintings was the absence of any focus or hierarchy: they seemed suspended, as though precluding closure.

Francis Bacon (1909–92, *see* page 118) bucked the trend towards abstraction – indeed, his famous series of 'Popes' recalled the portraiture of the seventeenth century. At the same time, however, his

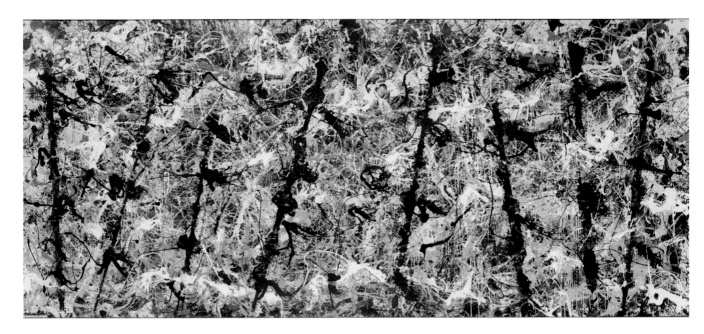

was a thoroughly modern take on the old ways: this was artistic 'representation' as it had never been seen before.

Pop Art

Outrageous as it was, Abstract Expressionism was in some ways utterly orthodox: these paintings were prestige items, created and collected by an elite. Romantic in spirit, they placed a premium on the creativity of the artist and the fellow-feeling of the viewer with the discrimination to respond. Art was a privileged communication between creative genius and connoisseur. To a new generation in the 1950s and 1960s, such art seemed an irrelevance, as TV, advertising, music promotion and other mass media bombarded the public with imagery. 'Pop art' was pioneered in Britain in the 1950s by artists such as Richard Hamilton (b. 1922) and Peter Blake (b. 1932). While it drew on Dada for its cheery way with absurdity and use of randomly 'found' objects, it derived a deeper inspiration from the mass media of the day.

Despite its UK origins, Pop was a natural 'fit' for US artists, brought up in the homeland of Hollywood: the capitalist capital of the world. While Andy Warhol (1928–87, *see* page 125) turned the most banal of commercial imagery into art, Roy Lichtenstein (1923–97, *see* page 123) found inspiration in the printed comic strip. Jasper Johns (b. 1930) found fresh energy through Pop art. As a young gay painter in the 1960s, Britain's David Hockney (b. 1937) followed Pop to Los Angeles, developing it in his own inimitable style.

Postmodernism

With styles and schools proliferating, art was evolving at an unprecedented rate: increasingly, its subject was art itself. In every area, from literature and film to philosophy, the basis of communication was being questioned. When we spoke, wrote, painted and played music, it was starting to be asked, did we in any real sense 'express ourselves' or did our language, culture or artistic conventions speak through us?

Op Art

Some set out to consider the very basis of visual illusion – fundamental to artistic enterprise since ancient times. The idea that art 'imitated' nature had been taken for granted. By the 1960s, though, artists such as Bridget Riley (b. 1931) were wondering what this meant. 'Op art' puns on 'Pop art', of course, and its works are invariably fun; taken collectively, though, they represent a serious attempt to engage with the processes of perception: the psychological underpinnings of our view of art.

Minimalism

Others reacted against what they saw as the lush overrichness of Abstract Expressionism. Rooted in Romanticism, it orchestrated big effects without interrogating the expressive values it enshrined. What was art actually about? We could hardly discover that by piling on imagery and colour; rather, we should dismantle art, strip it down to its bare bones. Hence the 'minimalist' efforts of practitioners in everything from music to interior design, and paintings by Robert Smithson (1938–73), Richard Allen (1933–99) and Anne Truitt (1921–2004).

Conceptualism

If the Abstract Expressionists could do without a subject, perhaps artists could do without paint and canvas or other materials: the important thing, surely, was to take art apart? The Dada-derived Spatialism of the Argentinian-Italian Lucio Fontana (1899–1968) had introduced art experiences in which not just an objective 'work' but also time and movement played their part.

Conversely, time was banished in Arte Povera ('impoverished art'); this used 'found' objects not for the absurd randomness they brought, but for their freedom from the backward-looking reference and allusiveness to earlier works which had until now seemed so central to the creation and enjoyment of great art. Conceptualism was to come of age in Britain, where the dapper double act of Gilbert and George (Gilbert Proesch, b. 1943, and George Passmore, b. 1942) burst on to the scene with their 'Performance Art' in 1970. The UK's claim to the Conceptualist copyright was strengthened by the birth of 'Britart' in the late 1980s; works such as the dead animal 'installations' of Damien Hirst (b. 1965) and the bed of Tracey Emin (b. 1963) interrogated the whole idea of the exhibited artwork.

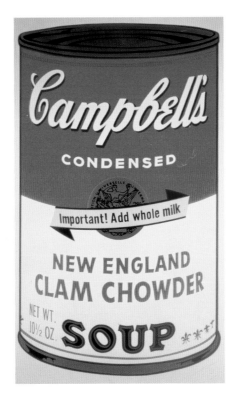

Neo-Expressionism

Conceptual art may have grabbed the headlines, but artists have still found new possibilities in older artistic forms. Among British artists, Sir Howard Hodgkin (b. 1932) has kept the abstract flame alive. Meanwhile, Portuguese-born Paula Rego (b. 1935) has reinvented the tradition of Expressionism in her hard-hitting works. Many of these can be seen to constitute narratives – like grotesquely parodied children's stories, often with animals assuming human roles (and clothing).

Contemporary

Where do we go from here? For one thing, we can look to the wider world, as art has been making an effort to transcend its European–North American 'comfort zone'. Colombia's Fernando Botero (b. 1932) and the Democratic Republic of Congo's Chéri Samba (b. 1956) are just two stars of a contemporary art scene which has grown increasingly international in recent years.

Alternatively, we can look on our doorsteps, because one of the most potent criticisms made of the biennale system is that, inclusive as it is geographically, it excludes real people – and so, some say, real art.

Street Art

A counterculture of 'street art' has arisen in response; the development of a tradition of guerrilla 'graffiti art' that began with Paris's Blek le Rat (Xavier Prou, b. 1952) and continued with New York's Jean-Michel Basquiat (1960–88) has reached a culmination with the interventions of the anonymous British Banksy. Ultimately, there is no telling where art will go next. The one thing we know for sure is that it will continue to transform itself, just as it has been doing for the last millennium and more.

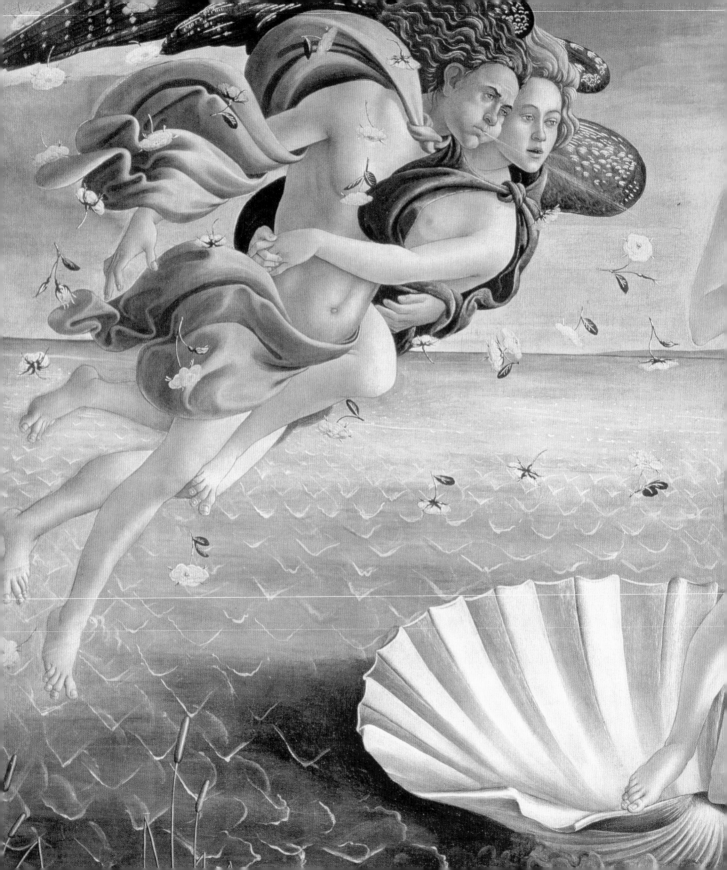

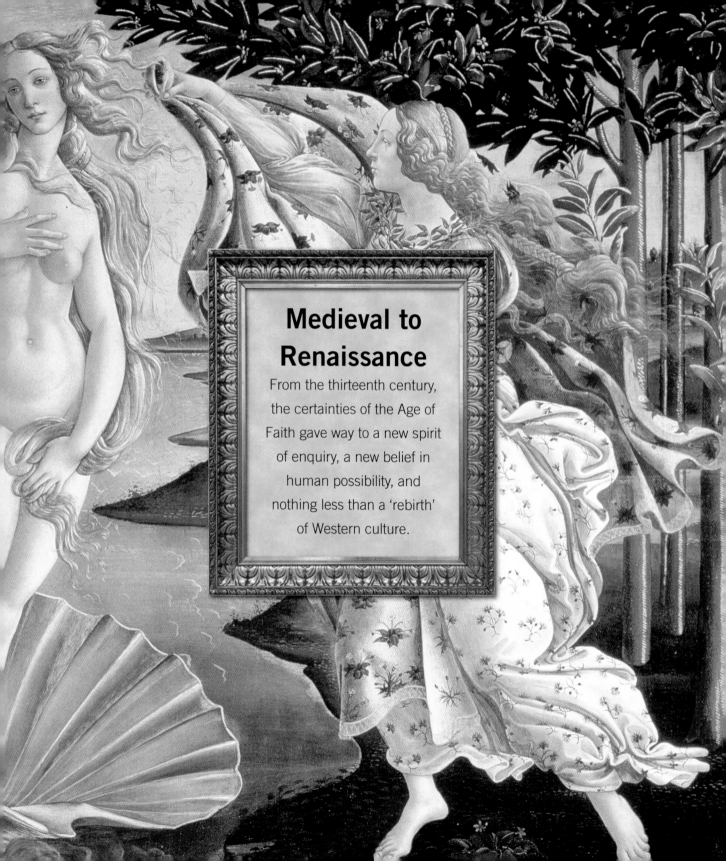

Medieval to Renaissance

From the thirteenth century, the certainties of the Age of Faith gave way to a new spirit of enquiry, a new belief in human possibility, and nothing less than a 'rebirth' of Western culture.

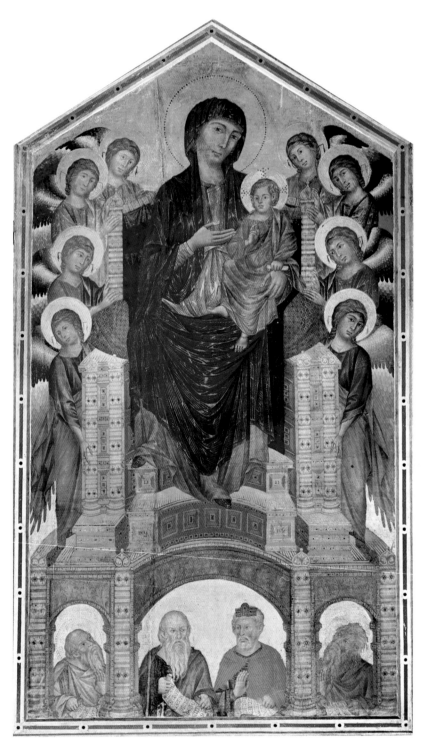

Cimabue (c. 1240–c. 1302)
Tempera on wood, 385 x 223 cm (151½ x 87¾ in)
• Galleria degli Uffizi, Florence

Madonna and Child Enthroned, *c.* **1280–85** The glorious radiance of Byzantine art lives on in the works of Cenni di Pepi or Cimabue but so, too, does a certain stiffness and an austere impersonality of tone.

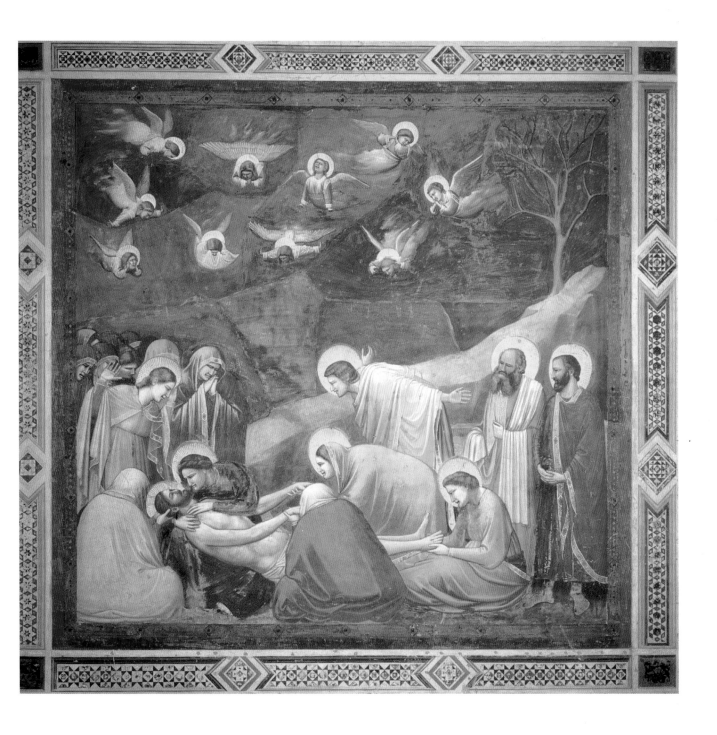

Giotto di Bondone (c. 1267–1337)
Fresco, 200 x 185 cm (78¾ x 72¾ in)
• Scrovegni Chapel, Padua

The Lamentation of Christ, *c.* 1305 Spare and stylized as they are, Giotto's frescoes show a new flexibility of form, a human quality that gives them an emotional impact of a quite unprecedented kind.

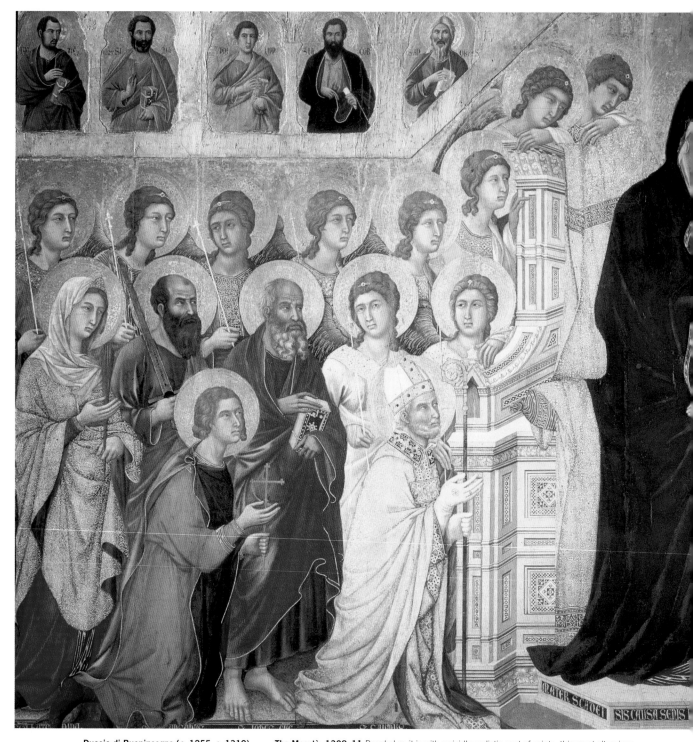

Duccio di Buoninsegna (*c.* 1255–*c.* 1319)
Tempera and gold on wood, 213 x 396 cm (84 x 156 in)
• Museo dell'Opera Metropolitana del Duomo, Siena

The Maestà, 1308–11 Peopled as it is with a vividly realistic cast of saints, this great altarpiece, created for the cathedral in Siena, marks a major break with Byzantine tradition.

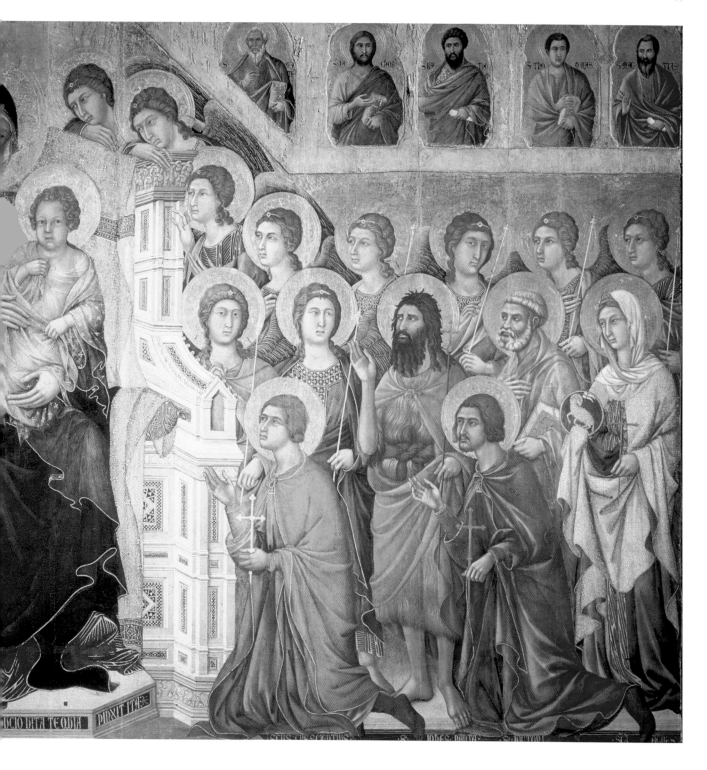

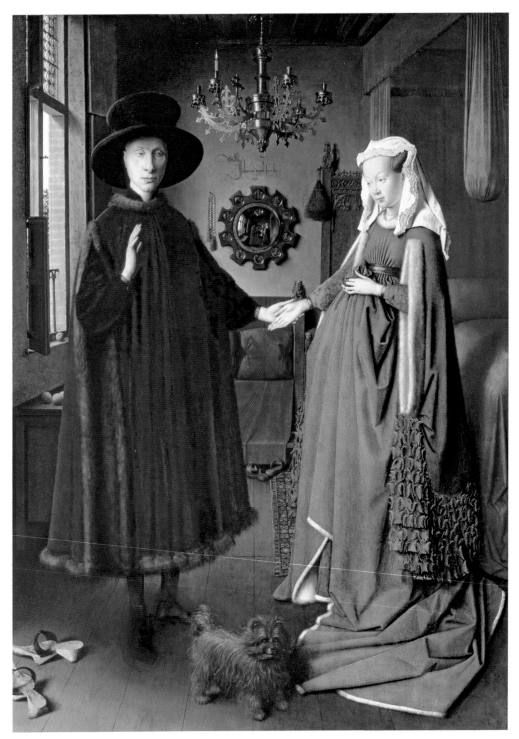

Jan van Eyck (*c.* 1389–1441)
Oil on panel, 82 x 59.5 cm (32¼ x 15½ in)
• National Gallery, London

The Arnolfini Portrait, 1434 Van Eyck's famous painting is the portrait not just of a couple but of a lifestyle, and of a quiet revolution in northern Europe where wealthy merchants were emerging as social leaders and artistic patrons.

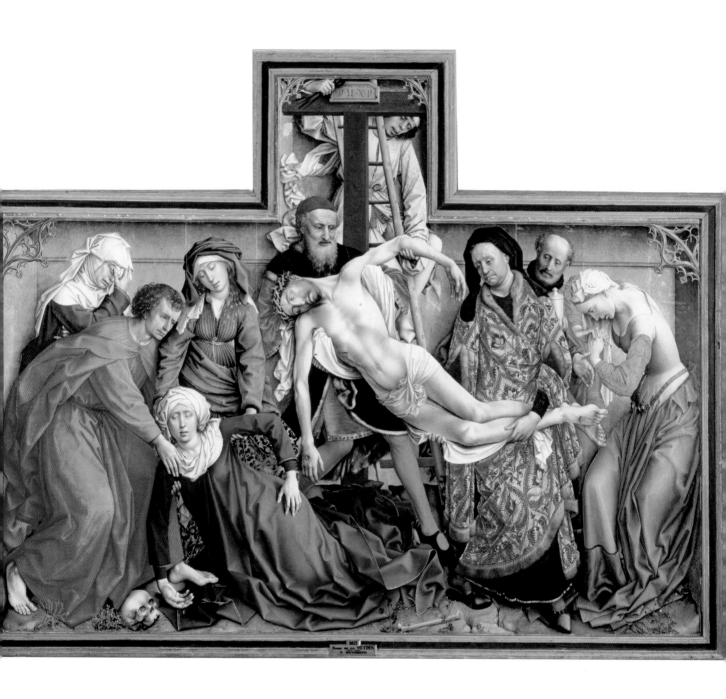

Rogier van der Weyden (*c.* 1399–1464)
Oil on panel, 220 x 262 cm (86½ x 103 in)
• Museo del Prado, Madrid

Descent from the Cross, *c.* 1435 Religion remained a central subject for northern European painting but a growing sense of individual psychology, along with freer-flowing artistic forms, fostered an emotional expressiveness which was wholly new.

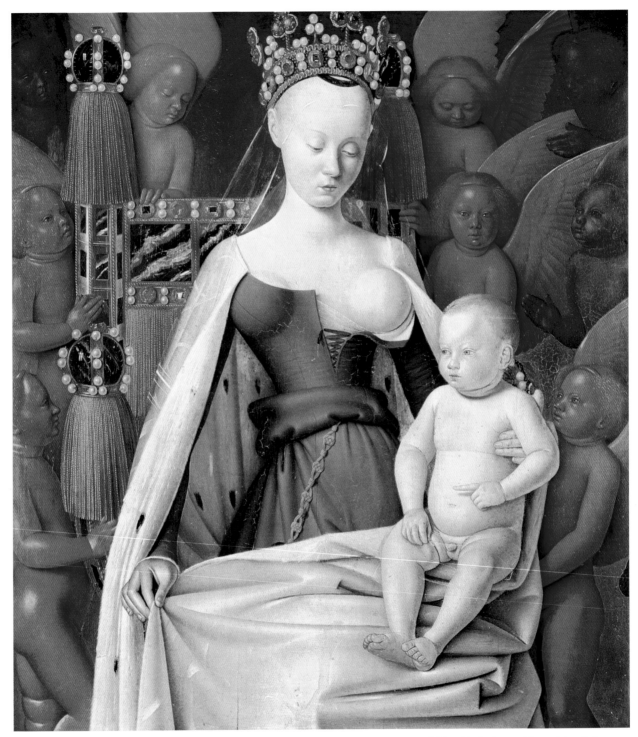

Jean Fouquet (c. 1420–81)
Oil on panel, 94.5 x 85.5 cm (37¼ x 33¾ in)
• Koninklijk Museum voor Schone Kunsten, Antwerp

Virgin and Child Surrounded by Angels, c. 1450 Regal in the Queen of Heaven's jewelled crown, Mary also stands as a symbol of motherhood, her breast displayed. Late-medieval art could be both a proclamation of prestige and an exploration of human feeling.

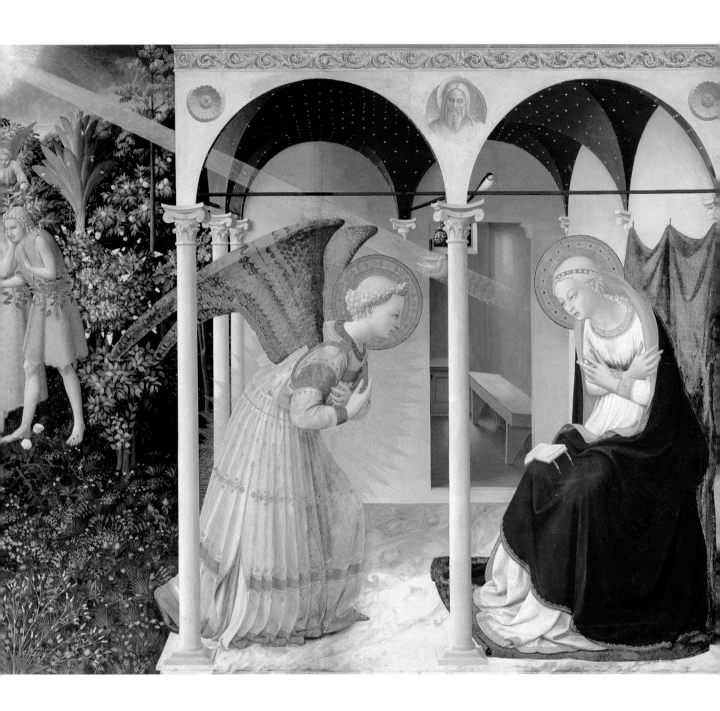

Fra Angelico (*c.* 1395–1455)
Tempera and gold on panel, 150 x 180 cm (59 x 71 in)
• Museo del Prado, Madrid

The Annunciation, *c.* 1426 His holiness and flair gained Giovanni of Fiesole the nickname 'Fra Angelico' (Angelic Friar). Here the Archangel Gabriel gives Mary the news that she is with child – and humankind the news of Christ's redemption.

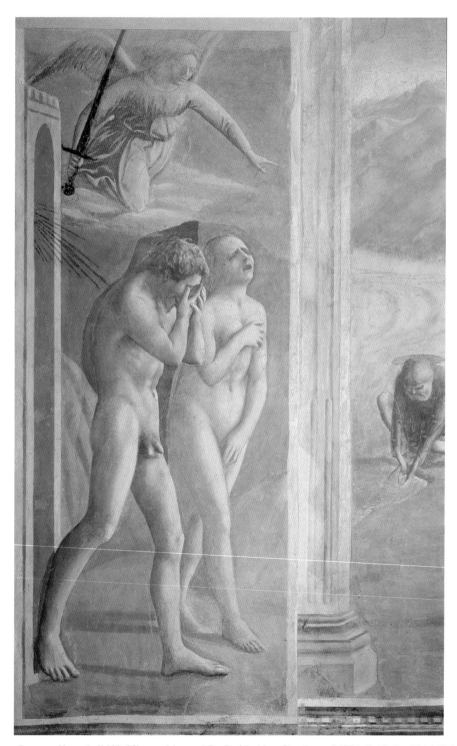

Tommaso Masaccio (1401–28)
Fresco, 208 x 88 cm (82 x 34½ in)
• Brancacci Chapel, Santa Maria del Carmine, Florence

Adam and Eve Banished from Paradise, *c.* 1427 In that first and fateful fall, a great medieval painter still finds hope in human feeling and in the beauties of the human form – that same hope on which the Renaissance was to be built.

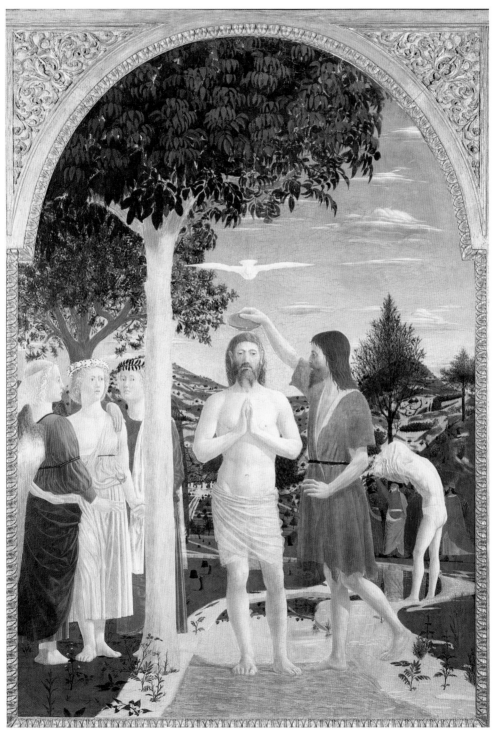

Piero della Francesca (c. 1420–92)
Tempera on panel, 167 x 116 cm (65¾ x 45¾ in)
• National Gallery, London

Baptism of Christ, c. 1450s Angels stand by and the Holy Spirit descends as a dove to bless the actions of John the Baptist by the River Jordan. A careful symmetry governs what remains a warmly human scene.

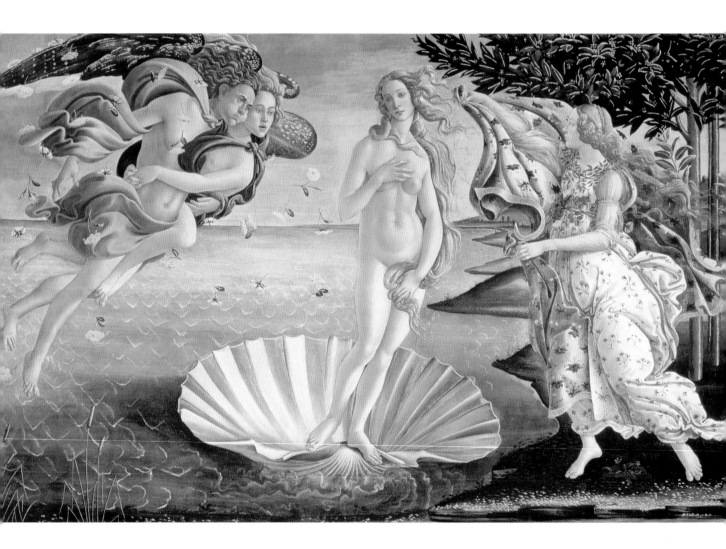

Sandro Botticelli (1445–1510)
Tempera on canvas, 278.5 x 172.5 cm (109½ x 68 in)
• Galleria degli Uffizi, Florence

The Birth of Venus, 1482–85 The goddess of love, in Roman mythology, was not actually born but emerged from the foam, fully formed in all her feminine glory. As imagined by Botticelli, she is the ultimate in beauty, fecundity and erotic promise.

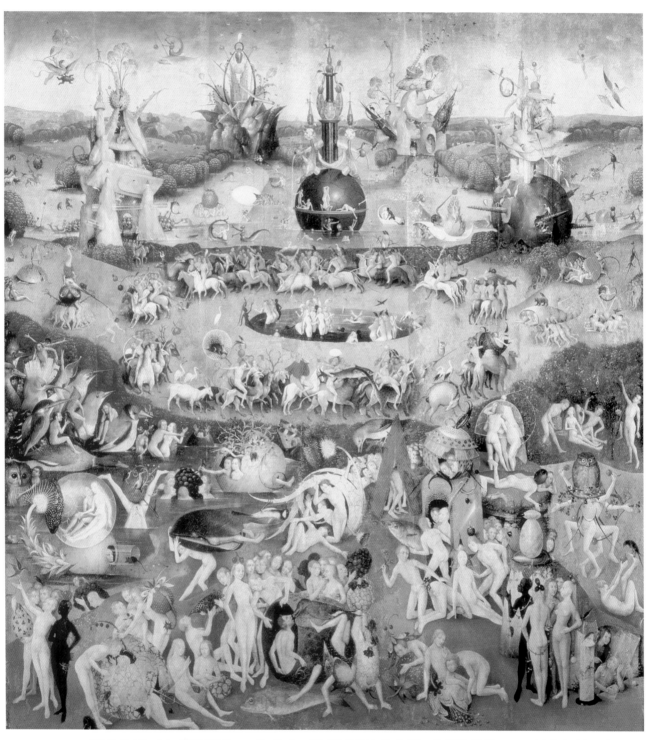

Hieronymus Bosch (*c.* 1450–1516)
Oil on panel, 220 x 195 cm (87 x 77 in)
• Museo del Prado, Madrid

The Garden of Earthly Delights (Central Panel), 1503–05 'The wages of sin is death,' said St Paul, but Christians could not help being tempted. Neither could medieval artists resist the allure of life's temptations – or Hell's torments – as striking subjects.

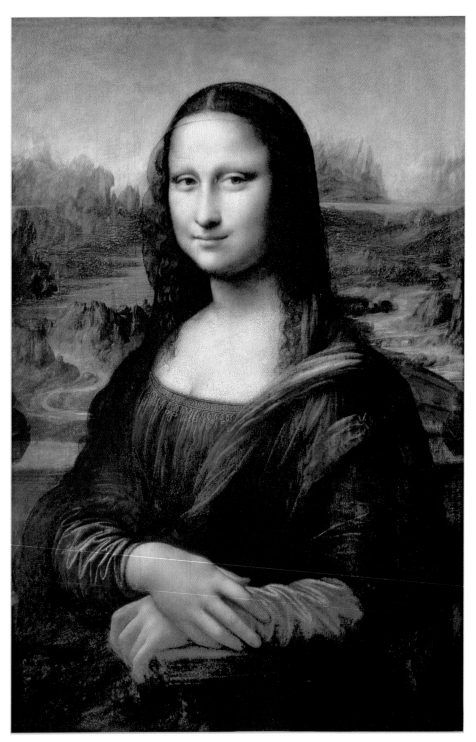

Leonardo da Vinci (1452–1519)
Oil on panel, 77 x 53 cm (30 x 21 in)
• Musée du Louvre, Paris

Mona Lisa, *c.* **1503–06** An ordinary merchant's wife … but as 'Mona Lisa' she became iconic. All femininity, all art are summed up in that smile. Unfathomable as she is, one thing is very clear: true beauty speaks to us across the centuries.

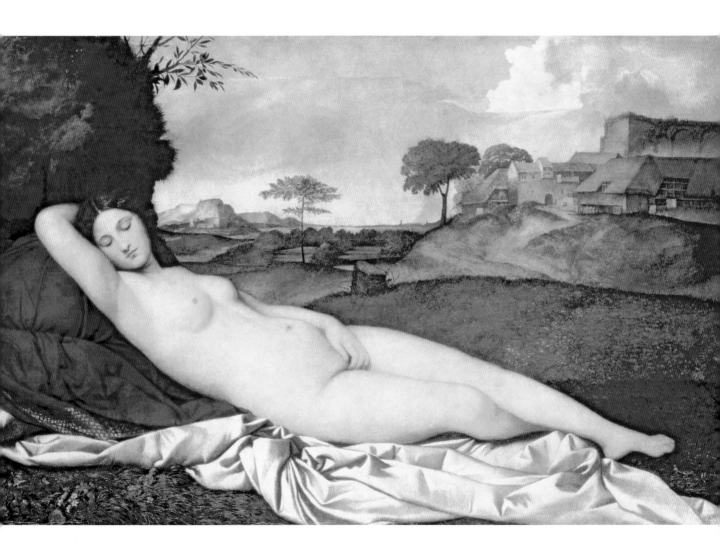

Giorgione (*c*.1478–1510)
Oil on canvas, 108.5 x 175 cm (42¾ x 69 in)
• Staatliche Kunstsammlungen, Dresden

The Sleeping Venus, 1508–10 At ease with herself and a landscape with which the curves of her body 'rhyme', the goddess appears entirely at home. Rejecting medieval denunciations of 'the world, the flesh and the devil', the Renaissance reinstated human beauty.

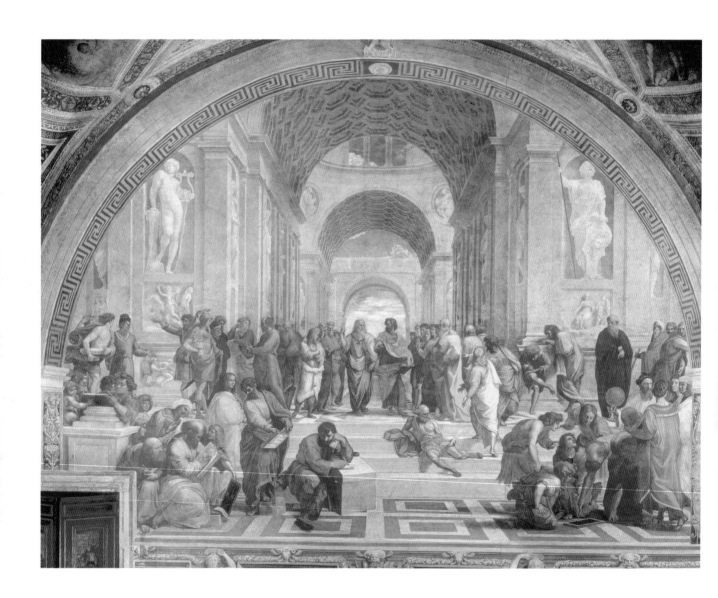

Raphael (1483–1520)
Fresco, 500 x 770 cm (197 x 303 in)
• Vatican Museum, Vatican City

School of Athens, 1510–11 Setting out to celebrate the achievements of the ancient philosophers, the modern painter did much more: this great fresco captures the spirit of the Renaissance in all its questing curiosity, its energy and its love of beauty.

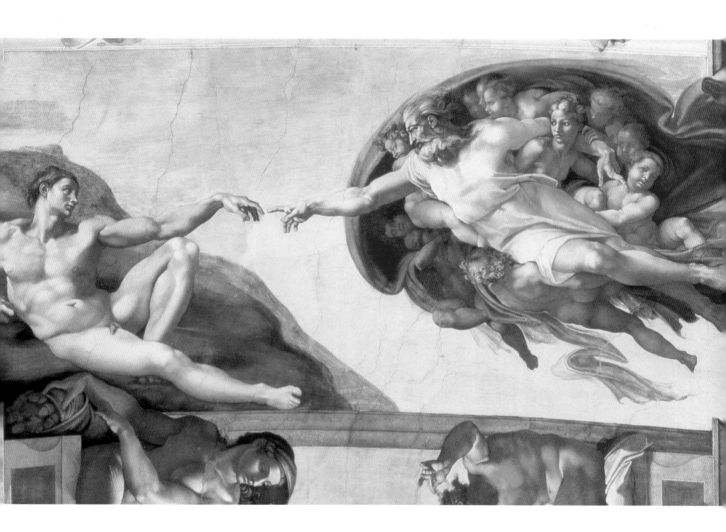

Michelangelo (1475–1564)
Fresco, 280 x 570 cm (110 x 224 in)
• Vatican Museum, Vatican City

The Creation of Adam, Sistine Chapel detail, 1511–12 Two fingers all but touching, yet what is truly eloquent is the space between. Ubiquitous as an emblem of inspiration, the image speaks too of a humanity fated always to fall short of the infinite for which it yearns.

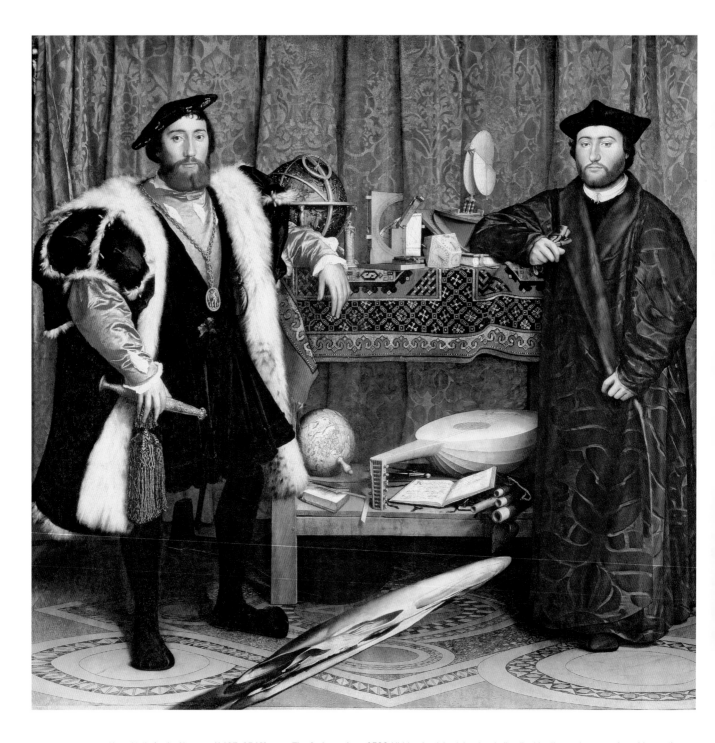

Hans Holbein the Younger (1497–1543)
Oil on panel, 207 x 209.5 cm (81 x 82½ in)
• National Gallery, London

The Ambassadors, 1533 Hidden in plain sight, the skull – tilted in distorted perspective – hints at the vanity of those splendid Renaissance achievements that the instruments of art and science on the table behind the two dignitaries seem to suggest.

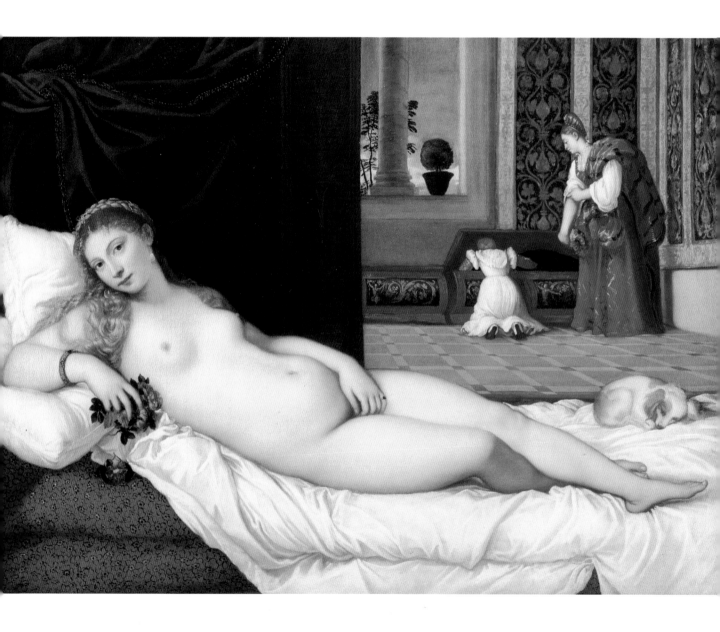

Titian (c. 1485–1576)
Oil on canvas, 119 x 165.5 cm (47 x 65¼ in)
• Galleria degli Uffizi, Florence

Venus of Urbino, 1538 Giorgione's goddess (*see* page 49) has been whisked indoors into luxurious surroundings. Wide awake, she meets the onlooker's eye. No nature-child, she represents an overtly seductive eroticism; a Venus of the boudoir, in other words.

Tintoretto (1518–94)
Oil on canvas, 405 x 405 cm (159 x 159 in)
• Pinacoteca di Brera, Milan

The Finding of the Body of St Mark, 1563–64 Seeking the evangelist's remains in the Alexandrian catacombs, Venetian pilgrims were hailed by the figure of the saint himself. The discovery became key to Venice's sense of its prestige. Tintoretto captures the moment in all its drama.

El Greco (1541–1614)
Oil on canvas, 460 x 360 cm (180 x 140 in)
• Santo Tomé, Toledo

Burial of Count Orgaz, 1586–88 Moved by the piety of this Spanish philanthropist, Saints Stephen and Augustine came down from heaven for his burial. The excitement is almost palpable; the sense of sacred mystery intense in one of El Greco's most extraordinary works.

Baroque to Romantic

The Renaissance had placed men and women at the centre of existence: even religious works were now expressions of humanity. Artistic creativity opened up a world of possibility, a world well worth exploring for its own sake.

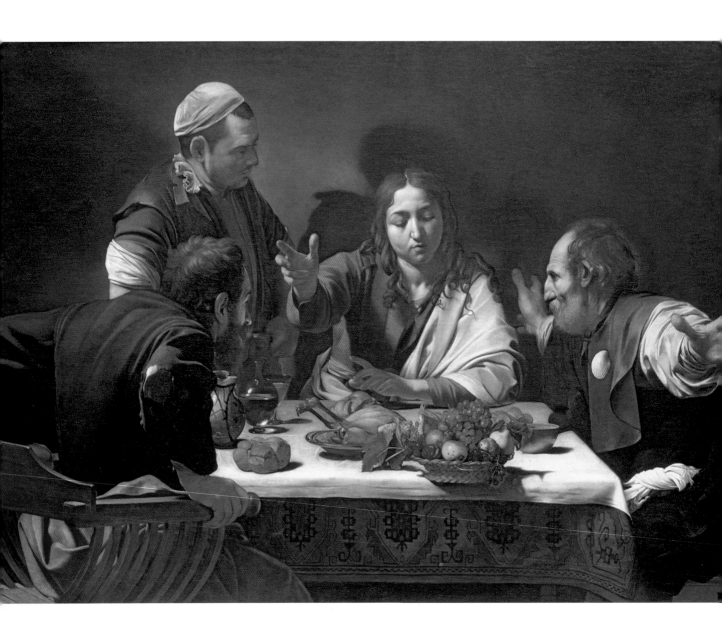

Caravaggio (1571–1610)
Oil and tempera on canvas, 141 x 196 cm (56 x 77 in)
• National Gallery, London

The Supper at Emmaus, 1601 Emotion is at the forefront, and dramatically so, in Caravaggio's account of the episode in which the risen Christ – till then unrecognized – revealed himself to his disciples in the breaking of the bread.

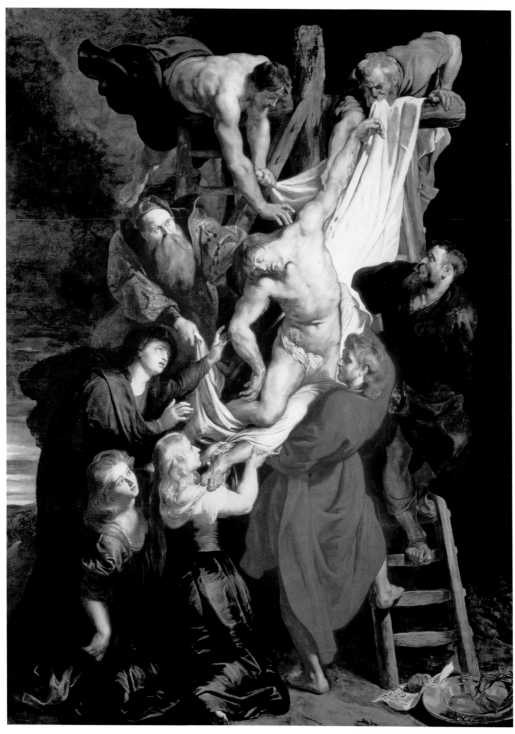

Peter Paul Rubens (1577–1640)
Oil on panel, 420.5 x 320 cm (165½ x 130 in)
• Cathedral of Our Lady, Antwerp

The Descent from the Cross, 1611–14 The body starkly stage-lit, the disciples' faces speak on our behalf and Christ's sacrifice is seen in strictly human terms. The theme may be divine but Rubens' appeal is overwhelmingly emotional. Religion was now about feeling rather than just thought.

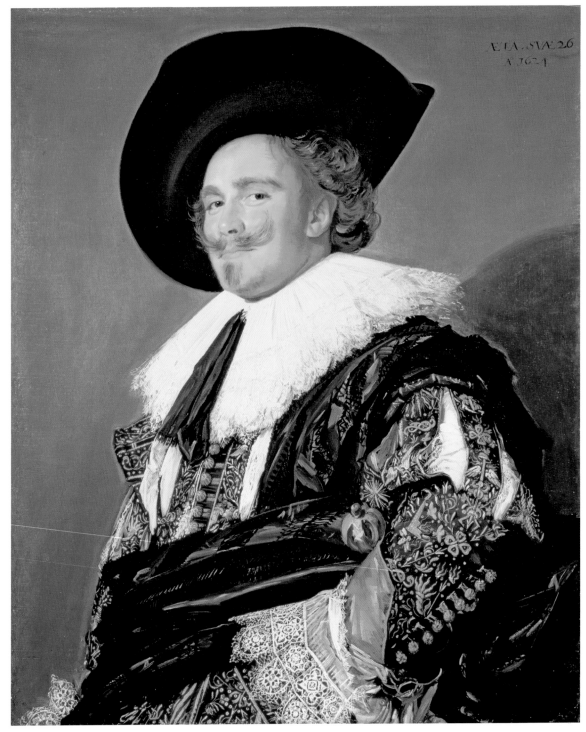

Frans Hals (*c.* 1580–1666)
Oil on canvas, 83 x 67 cm (32¾ x 26½ in)
• Wallace Collection, London

The Laughing Cavalier, 1624 'Drama' does not have to mean 'melodrama', nor were the great paintings of the Baroque necessarily all doom and gloom. Here the vivid warmth and lively immediacy captivate in Hals' most celebrated work.

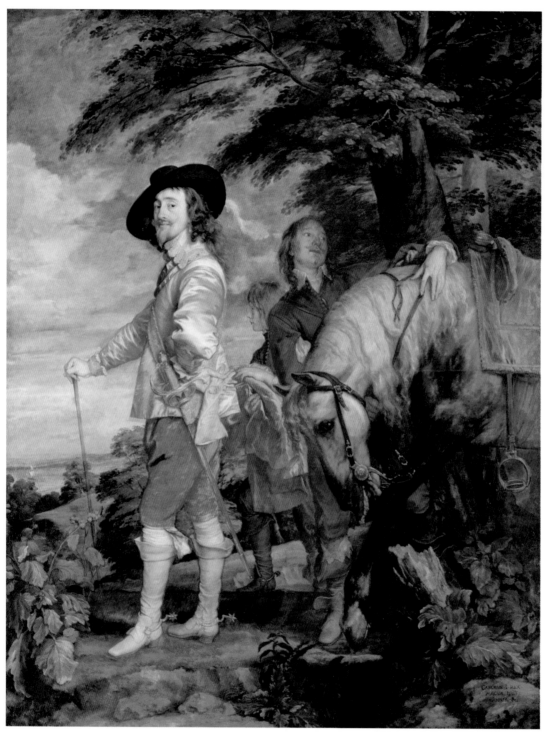

Anthony van Dyck (1599–1641)
Oil on canvas, 266 x 207 cm (104¾ x 81½ in)
• Musée du Louvre, Paris

King Charles I of England Out Hunting, *c.* 1635 Smart, casual and yet every inch a king, England's most autocratic ever monarch cuts a quietly impressive figure in a work designed to affirm his effortless poise in the most informal of situations.

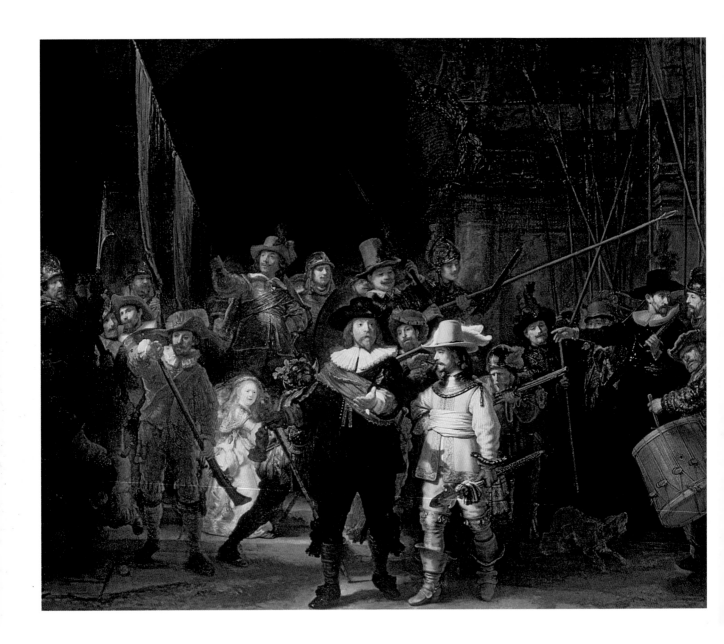

Rembrandt van Rijn (1606–69)
Oil on canvas, 363 x 437 cm (143 x 172 in)
• Rijksmuseum, Amsterdam

The Night Watch, 1642 *Chiaroscuro* is key to the powerful impact of the best Baroque painting; the Italian term means, literally, 'light-dark'. And no one mastered the technique more completely than Rembrandt, as exhibited in his most famous work.

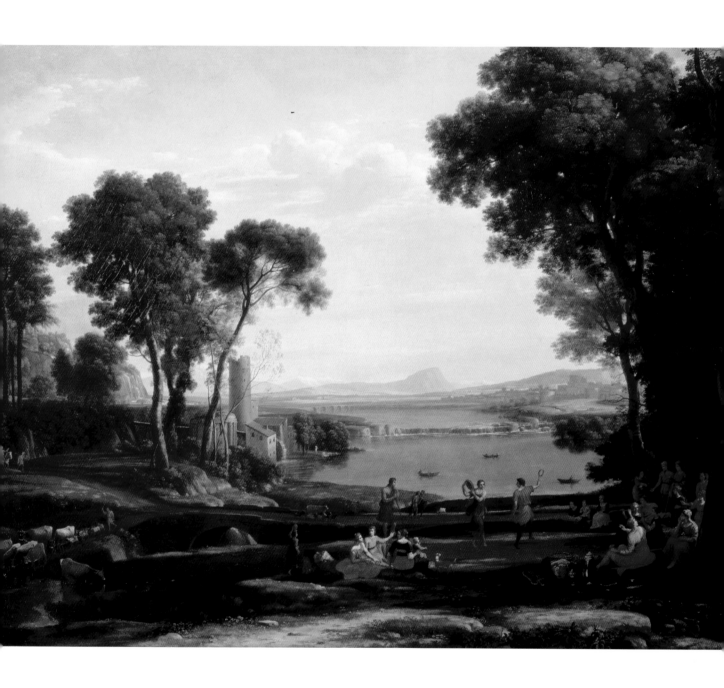

Claude Lorrain (1600–82)
Oil on canvas, 197 x 149 cm (77½ x 58½ in)
• National Gallery, London

Landscape with the Marriage of Isaac and Rebecca (The Mill), 1648 Previously but a background, landscape was now a subject in its own right, its human occupants almost incidental, it could seem. Even so, for the greatest painters nature and its beauty offered another means of emotional expression.

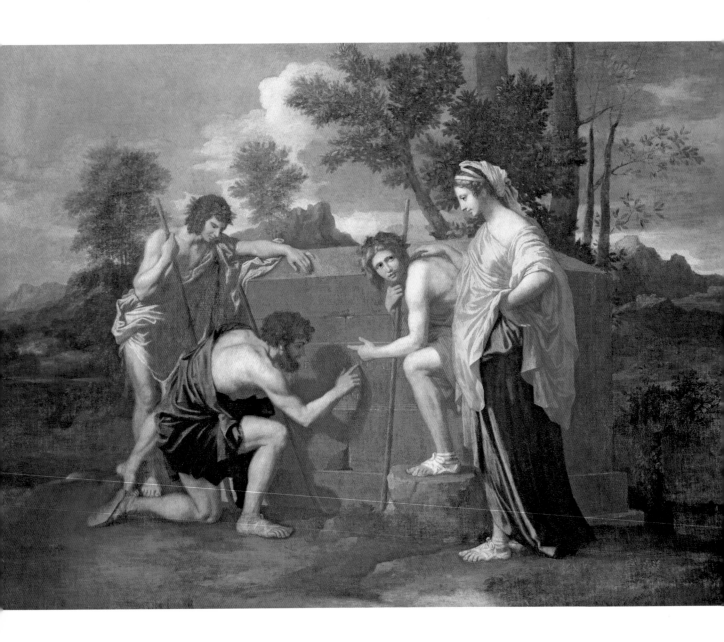

Nicolas Poussin (1594–1665)
Oil on canvas, 87 x 120 cm (34¼ x 47¼ in)
• Musée du Louvre, Paris

Et in Arcadia Ego (The Arcadian Shepherds), *c.* **1650** 'Even in Arcadia, I am to be found,' says Death to the wondering shepherds, the contentment of their golden-age existence rudely shattered. Even at its most sedate-seeming, great art brings us up against deep realities.

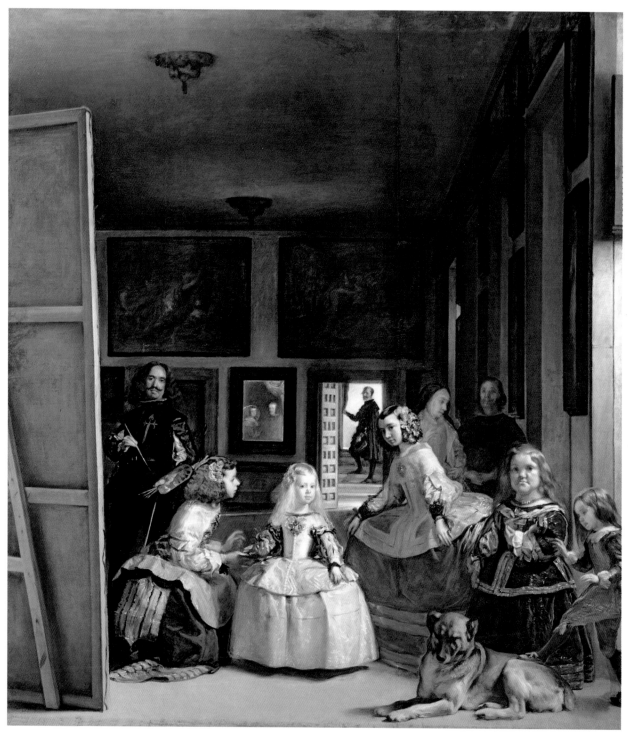

Diego Velázquez (1599–1660)
Oil on canvas, 318 x 276 cm (125¼ x 108¾ in)
• Museo del Prado, Madrid

Las Meninas, c. 1656 Who is looking at whom? Who is portraying what? Which is the subject, which the background here? Bustling about the little princess, the young attendants reflect her regal status, yet we are drawn to the painter viewing his own work.

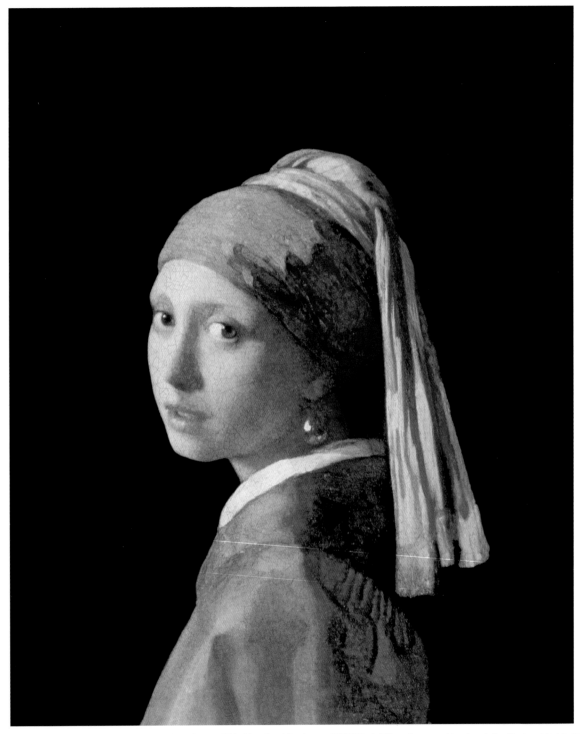

Johannes Vermeer (1632–75)
Oil on canvas, 44.5 x 39 cm (17½ x 15 in)
• Mauritshuis, The Hague

Girl with a Pearl Earring, c. 1665 The 'girl' is unknown yet her face is familiar to art lovers everywhere. This is the essential paradox of Dutch interior art. The utterly mundane is miraculously transformed, as is this girl's expression in its luminous beauty.

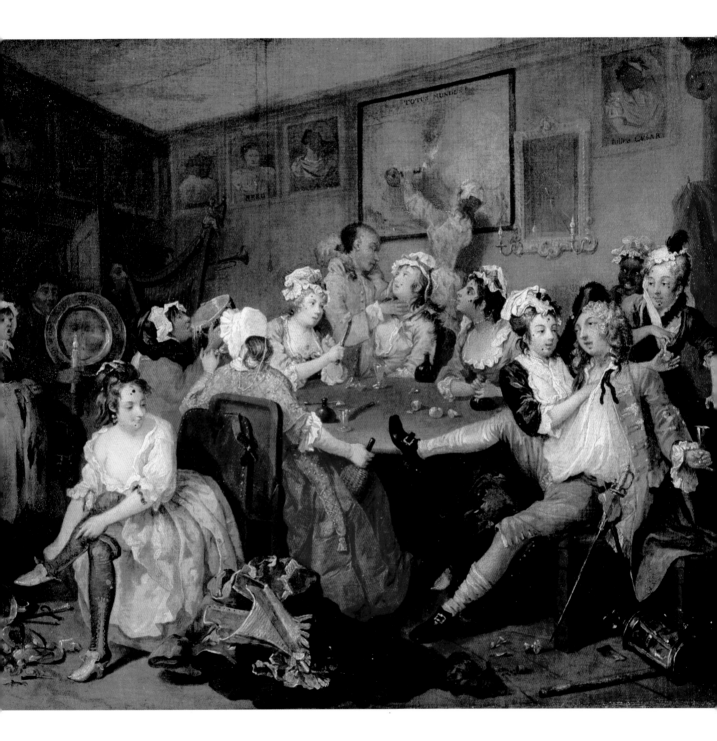

William Hogarth (1697–1764)
Oil on canvas, 62.5 x 75 cm (24½ x 29½ in)
• Sir John Soane's Museum, London

Rake's Progress III (At the Rose Tavern), 1733 The story of a young gentleman's descent into dissipation and thence into ruin, Hogarth's satiric sequence, though beautifully painted, is clearly kin to the cartoons then sending up the excesses of London life.

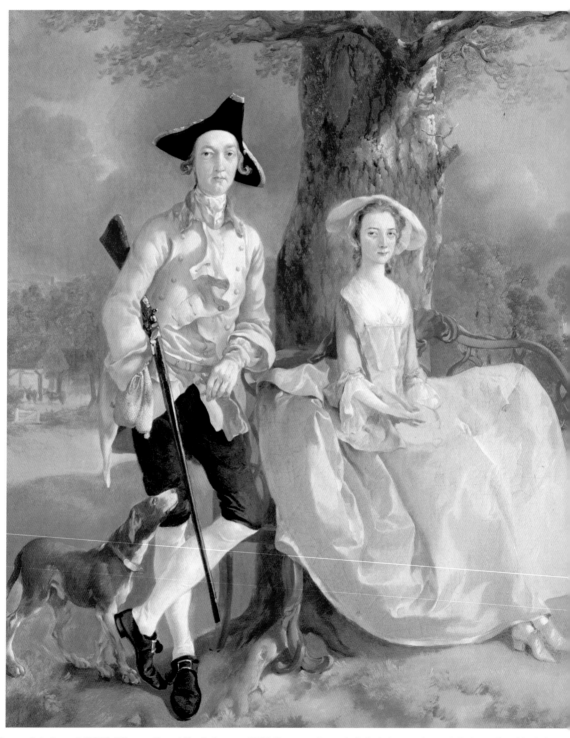

Thomas Gainsborough (1727–88)
Oil on canvas, 69 x 119 cm (27¼ x 47 in)
• National Gallery, London

Mr and Mrs Andrews, *c.* **1750** The easy-going portrait of a loving couple or a defiant assertion of landed affluence and power, this famous painting has divided critical opinion in recent years. What cannot be disputed is Gainsborough's surpassing skill.

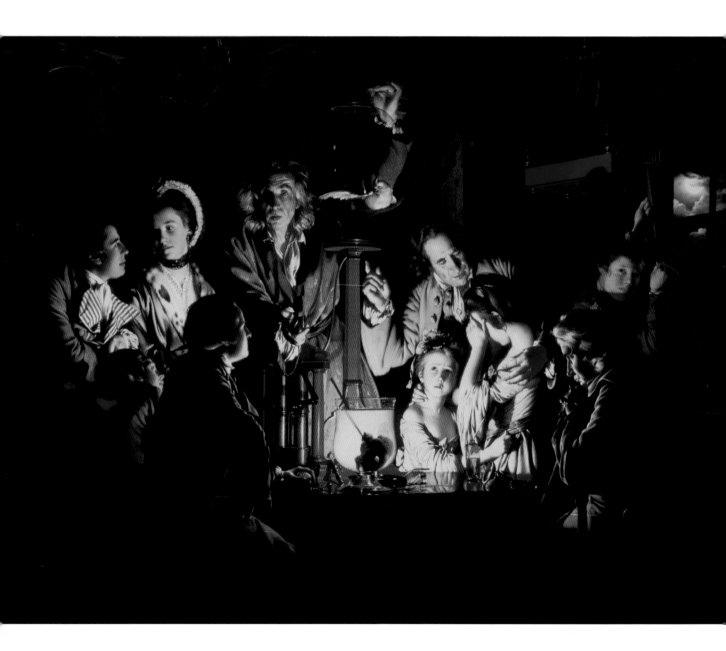

Joseph Wright (1734–97)
Oil on canvas, 183 x 244 cm (72 x 94½ in)
• National Gallery, London

An Experiment on a Bird in the Air Pump, 1768 The *chiaroscuro* is arresting, but the light once reserved for religious grace now doubles as the light of scientific insight. Working on the eve of the Industrial Revolution, Wright saw beauty in enquiry, however cruel.

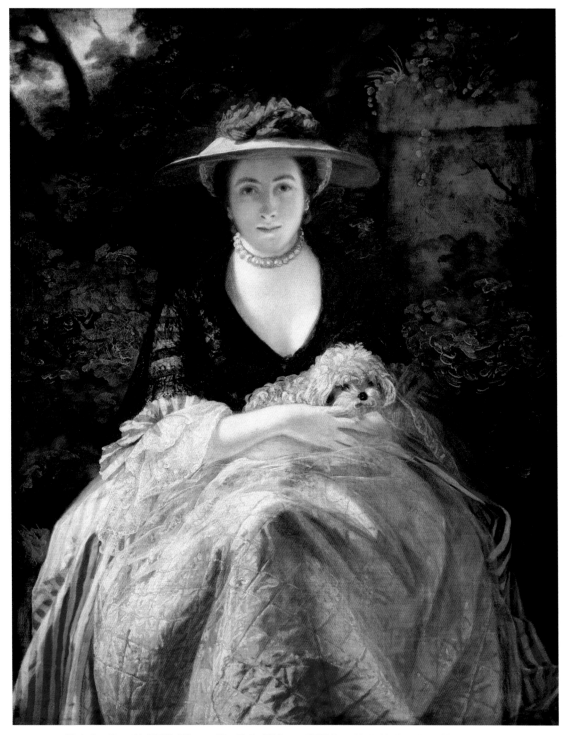

Sir Joshua Reynolds (1723–92)
Oil on canvas, 126 x 110 cm (49½ x 43¼ in)
• Wallace Collection, London

Miss Nelly O'Brien, *c.* 1763 Reynolds, in idealizing his subjects, had a way of aggrandizing them as well. Miss O'Brien, a famous courtesan, was also the artist's friend, a fact which surely shines through in the warmth and liveliness of this portrait.

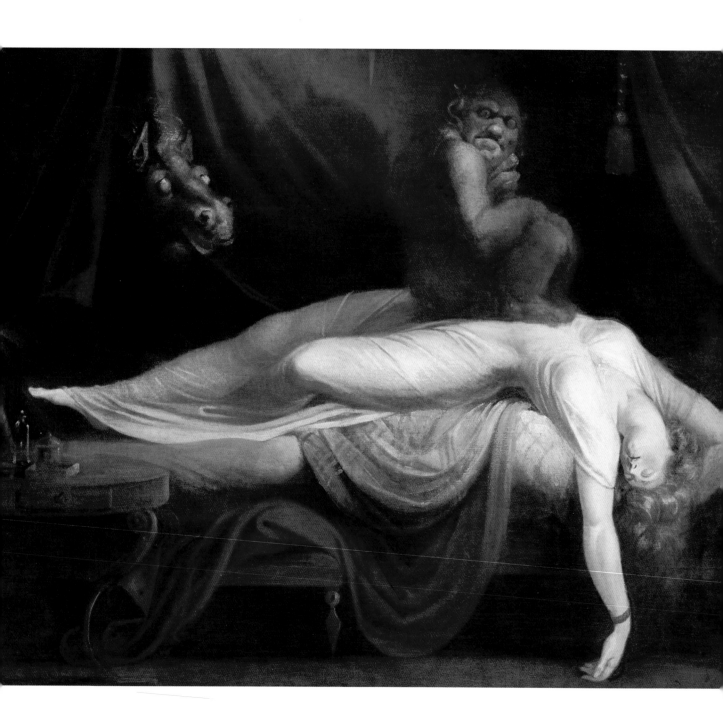

Henry Fuseli (1741–1825)
Oil on canvas, 101.5 x 127 cm (40 x 50 in)
• Detroit Institute of Arts, Detroit

The Nightmare, 1781 We see dreamer and dream at once in this extraordinary work, the most famous painterly equivalent to the 'gothic' strand which crept into some of the most memorable English fictions of the late eighteenth century.

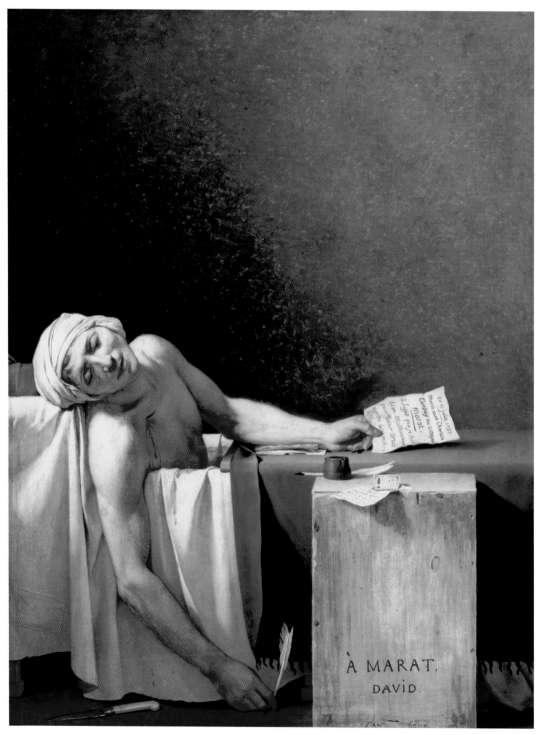

Jacques-Louis David (1748–1825)
Oil on canvas, 165 x 128 cm (65 x 50 in)
• Musées Royaux des Beaux-Arts de Belgique, Brussels

The Death of Marat, 1793 David's 'neoclassical' style was not just aesthetic but ideological, tricking out the Terror in the dignified robes of Rome. His friend Jean-Paul Marat, a radical revolutionary, was as much an executioner as a martyr.

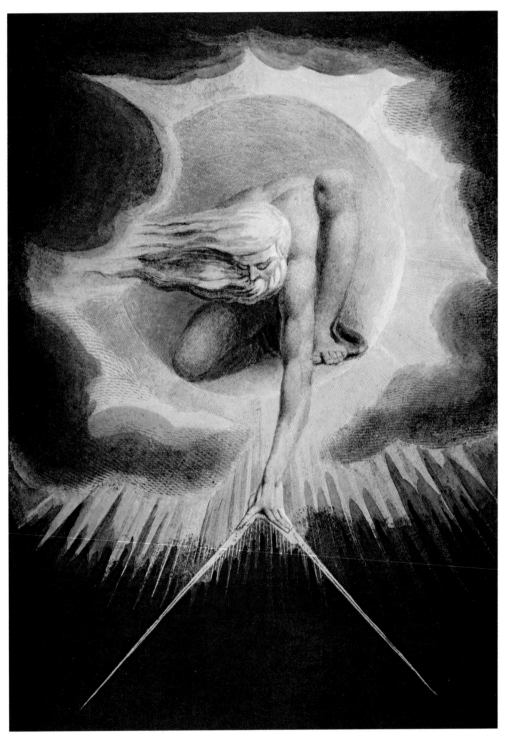

William Blake (1757–1827)
Etching with pen and ink, watercolour and bodycolour on paper,
36 x 25.5 cm (14 x 10 in) • Private Collection

The Ancient of Days, 1794 The 'Ancient of Days', as the Book of Daniel describes him, is God the great creator. Blake's famous etching shows him leaning down from heaven, imposing order on the primal chaos.

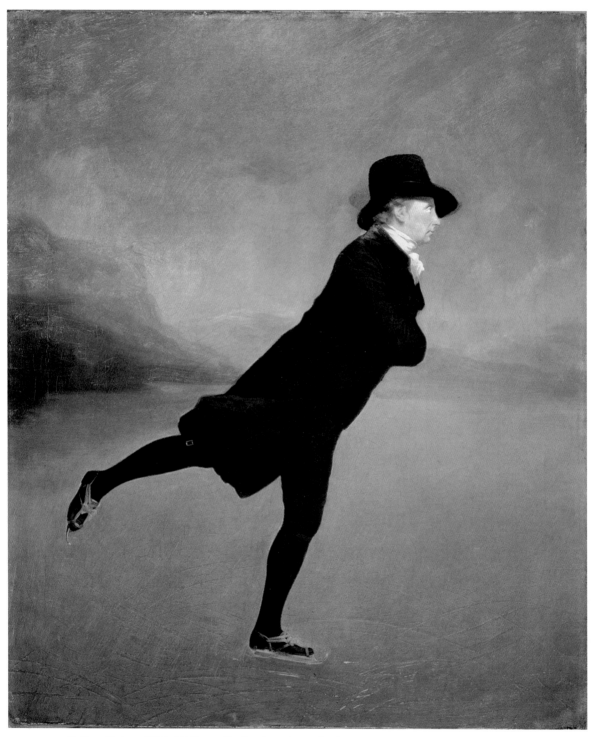

Sir Henry Raeburn (1756–1823)
Oil on canvas, 76 x 64 cm (30 x 25 in)
• Scottish National Gallery, Edinburgh

The Rev. Robert Walker Skating on Duddingston Loch, *c.* 1795 A stunning symphony in black and grey, a masterpiece of incongruity, Raeburn's painting is puzzling in its appeal. Ultimately, perhaps, it sums up the contradictory spirit of the Scottish Enlightenment: drab and yet exciting, dour yet daring.

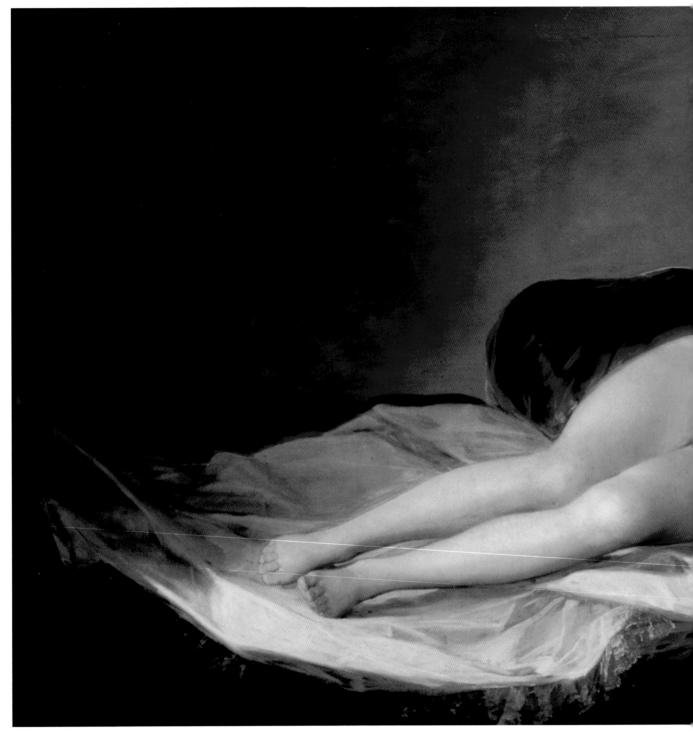

Francisco de Goya (1746–1828)
Oil on canvas, 98 x 191 cm (38½ x 75¼ in)
• Museo del Prado, Madrid

The Naked Maja, 1797–1800 A cheeky, cheerful young woman of the lower class, the *maja* became a stereotypical figure in Spain. Stunning in itself, Goya's famous work may also poke fun at the many earlier, more supposedly serious, mythologically exalted nudes.

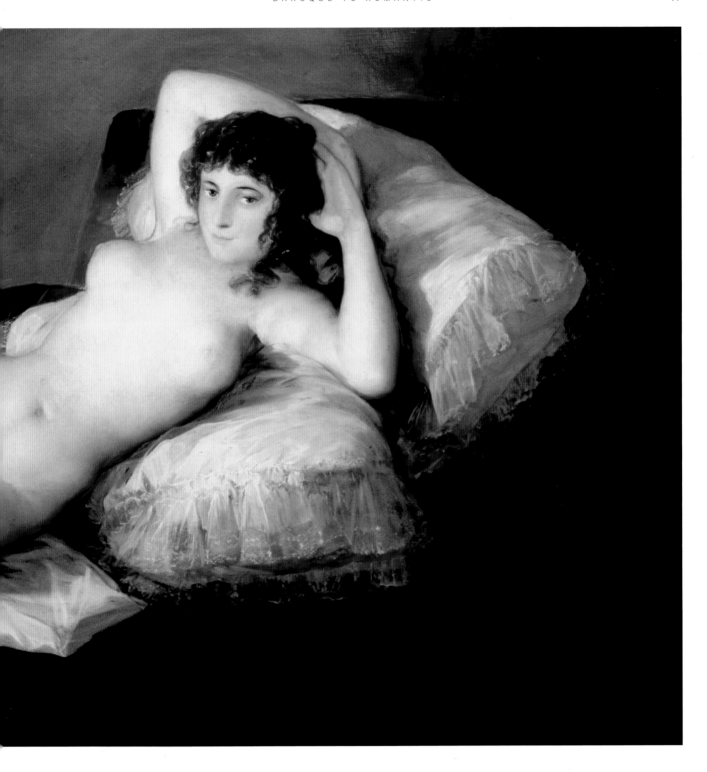

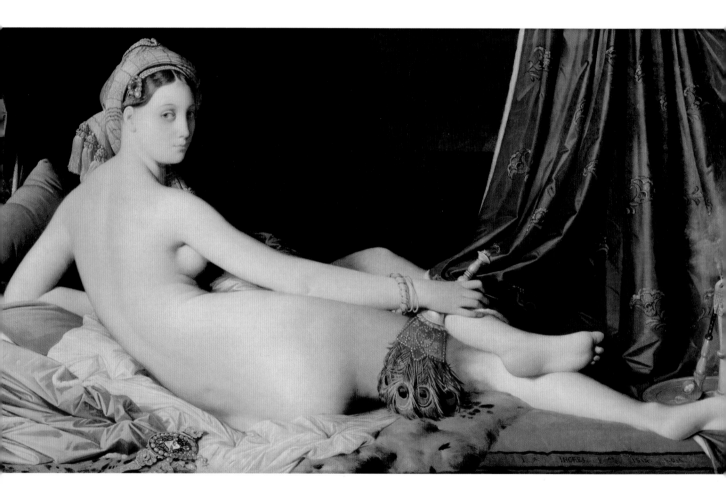

Jean-Auguste-Dominique Ingres (1780–1867)
Oil on canvas, 89 x 162.5 cm (35 x 64 in)
• Musée du Louvre, Paris

La Grande Odalisque, 1814 Lithe and (unfeasibly) sinuous, Ingres' temptress looks back unperturbedly into the viewer's gaze. An Ottoman court-concubine, the *odalisque* stirred the imagination of a Romantic culture which saw the East as a place of exotic (and erotic) promise.

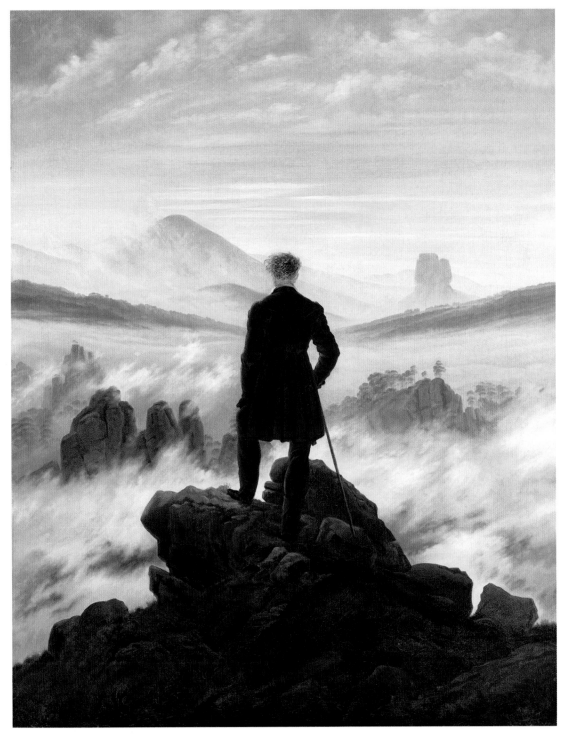

Caspar David Friedrich (1774–1840)
Oil on canvas, 98.5 x 75 cm (37¼ x 29½ in)
• Hamburger Kunsthalle, Hamburg

The Wanderer above the Sea of Clouds, 1818 Romanticism brought landscape into the artistic foreground, exploring the expressive possibilities of the natural scene. In extreme cases, however (in Byron's poems as in Friedrich's paintings), it became a mere metaphor for the anguish of the questing soul.

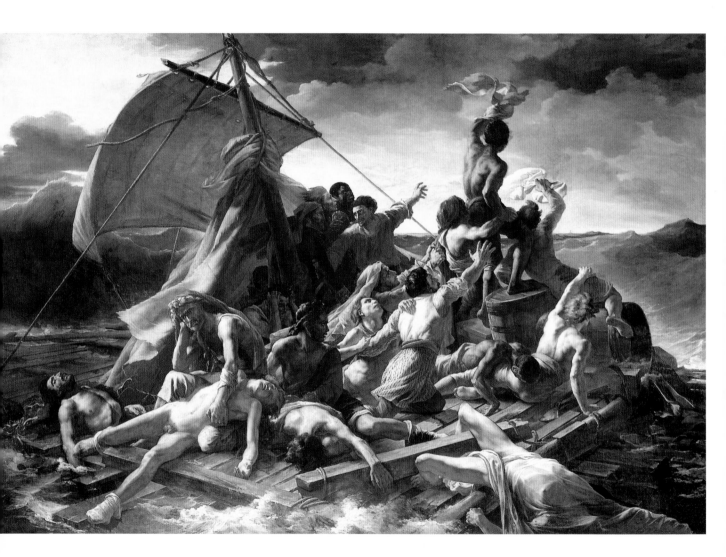

Théodore Géricault (1791–1824)
Oil on canvas, 491 x 716 cm (193¼ x 282¼ in)
• Musée du Louvre, Paris

The Raft of the Medusa, 1819 A sail! Deliverance is at last at hand for the survivors of the shipwrecked frigate, *Méduse*, after 13 days adrift. Their unimaginable sufferings and the suspicion of unspeakable crimes (even cannibalism), appealed to a Romantic interest in the extreme.

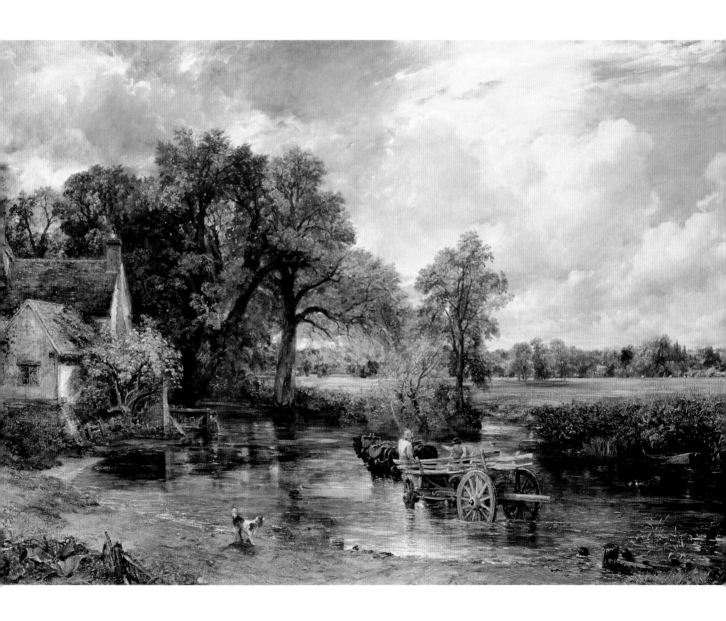

John Constable (1776–1837)
Oil on canvas, 130 x 185 cm (51¼ x 72¾ in)
• National Gallery, London

The Hay Wain, 1821 The contrast with Friedrich's work (*see* page 79) could hardly be more clear: all is peaceful on Suffolk's River Stour, the fording hay-cart completely unthreatened whilst nature (suggests the mill) works in contented co-operation with humankind.

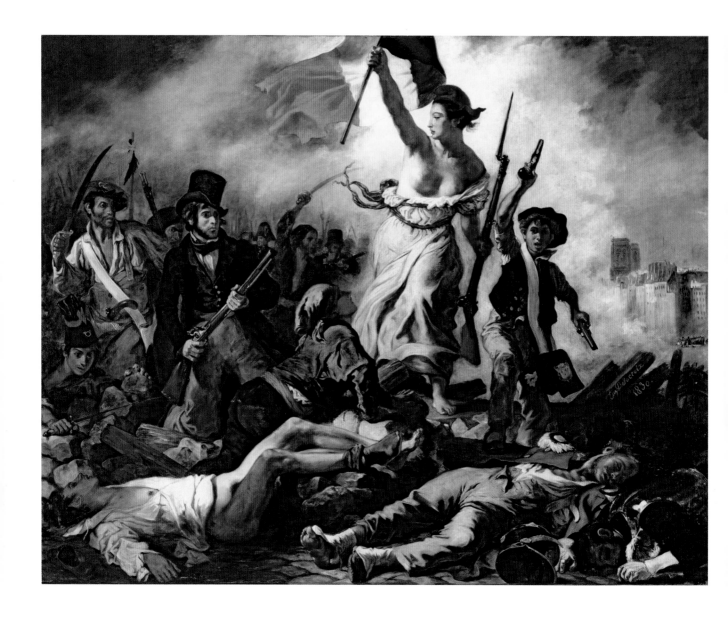

Eugène Delacroix (1798–1863)
Oil on canvas, 260 x 325 cm (102½ x 128 in)
• Musée du Louvre, Paris

Liberty Leading the People, 1830 The personification of the French Republic, 'Marianne' combines the statuesque poise of a classical goddess with the strong-armed feistiness of the working woman. Here, heroically, she leads the charge against monarchical oppression.

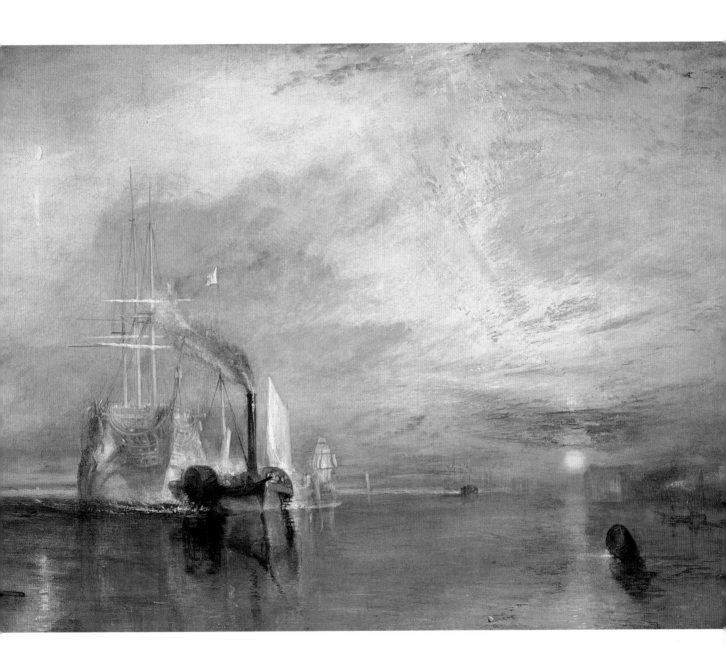

J.M.W. Turner (1775–1851)
Oil on canvas, 91 x 122 cm (36 x 48 in)
• National Gallery, London

The Fighting Temeraire, 1839 The sun sets on an era, and not just on the sailing ship being towed to the breaker's yard by paddle steamer. Turner's work represents a new dawn in landscape painting, truly Romantic in its passion and in its daring.

Impressionist to Modern

The second half of the nineteenth century saw an increasing readiness to experiment on the artists' part: first to find new and better methods of *mimesis* – or imitating nature – and later to leave representational forms behind.

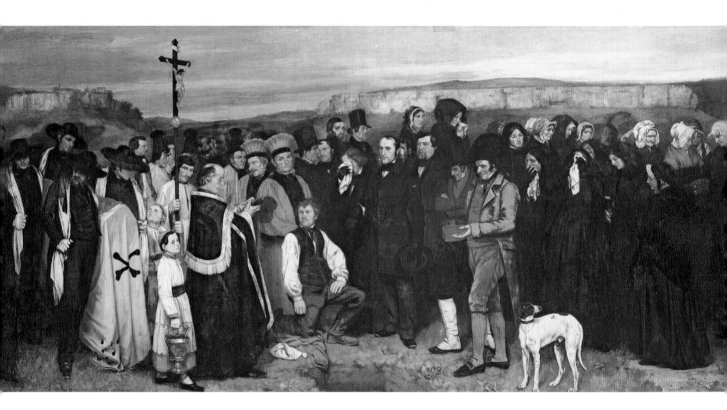

Gustave Courbet (1819–77)
Oil on canvas, 315 x 660 cm (124 x 260 in)
• Musée d'Orsay, Paris

Burial at Ornans, 1849–50 A small-town funeral takes on an epic grandeur in a work that caused a sensation when it first appeared. Ornans was the artist's place of birth and the deceased was a relation, as were many of those attending.

Ford Madox Brown (1821–93)
Oil on panel, 82.5 x 75 cm (32 x 29 in)
• Birmingham Museums and Art Gallery, Birmingham

The Last of England, 1852–55 Their expressions set in resigned resolution as the White Cliffs of Dover slip by astern, an emigrant couple contemplate the uncertainties ahead. In his concern for verisimilitude, Madox Brown took himself and his wife as his models.

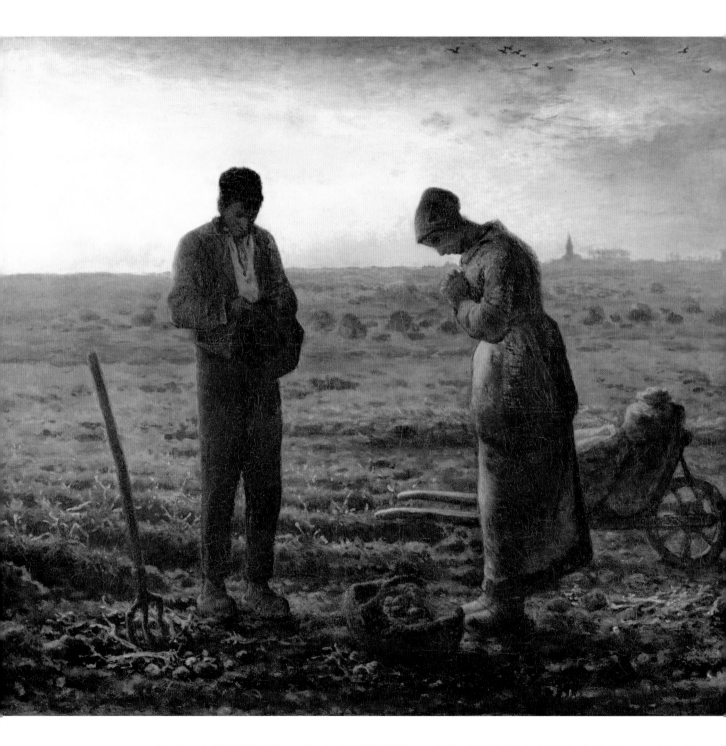

Jean-François Millet (1814–75)
Oil on canvas, 55.5 x 66 cm (22 x 26 in)
• Musée d'Orsay, Paris

The Angelus, 1857–59 The sound of the church bell at six o'clock signalled that the peasants' working day could end with a collective prayer to Our Lady in honour of the Annunciation. Millet's realism found a poetry in rural life.

James Abbott McNeill Whistler (1834–1903)
Oil on canvas, 144 x 162.5 cm (56¾ x 64 in)
• Musée d'Orsay, Paris

Arrangement in Grey and Black No. 1, Portrait of the Artist's Mother, 1871 This experiment in colour and form was received so enthusiastically as a study in motherhood and middle-class respectability that its artistic implications were largely lost. In hindsight Whistler's kinship with the French Impressionists is clear.

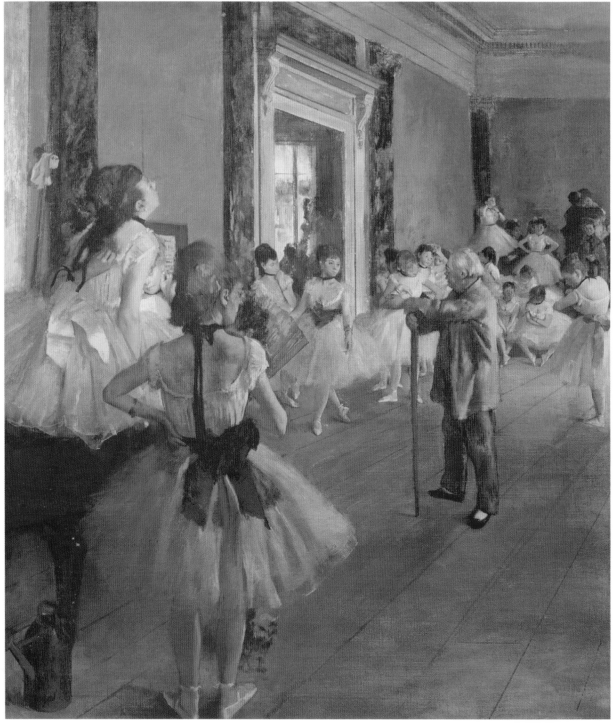

Edgar Degas (1834–1917)
Oil on canvas, 85 x 75 cm (33½ x 29½ in)
• Musée d'Orsay, Paris

The Ballet Class, *c.* **1871–74** For Degas, a grainy floor was as absorbing a challenge as a silken ribbon or a diaphanous dress – but the movements and the gestures of the dancers were what really caught his artist's eye.

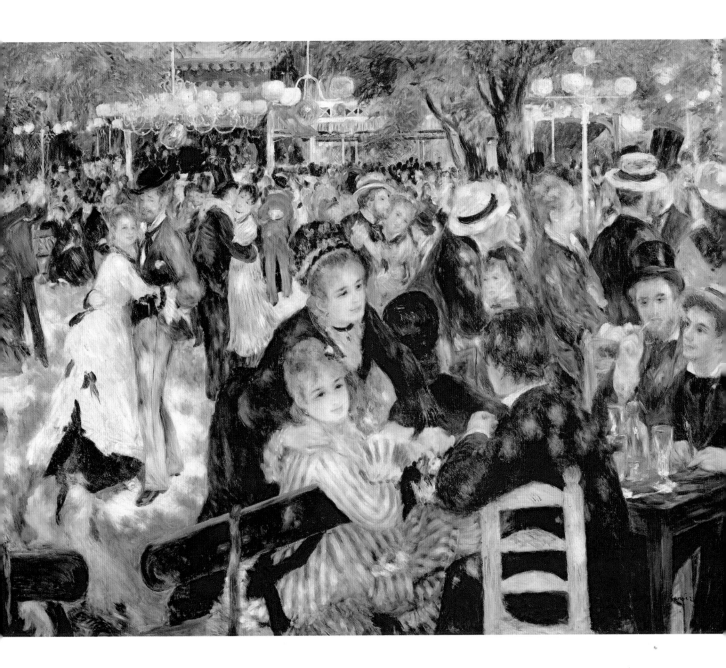

Pierre-Auguste Renoir (1841–1919)
Oil on canvas, 131 x 175 cm (52 x 69 in)
• Musée d'Orsay, Paris

Dance at the Moulin de la Galette, 1876 An Impressionist, a consummate artist, but also a 'people person', Renoir's popularity is not hard to understand. Sunlight-dappled dresses, straw hats and smiling faces – the warmth of a summer's afternoon radiates from this painting of Parisians at play.

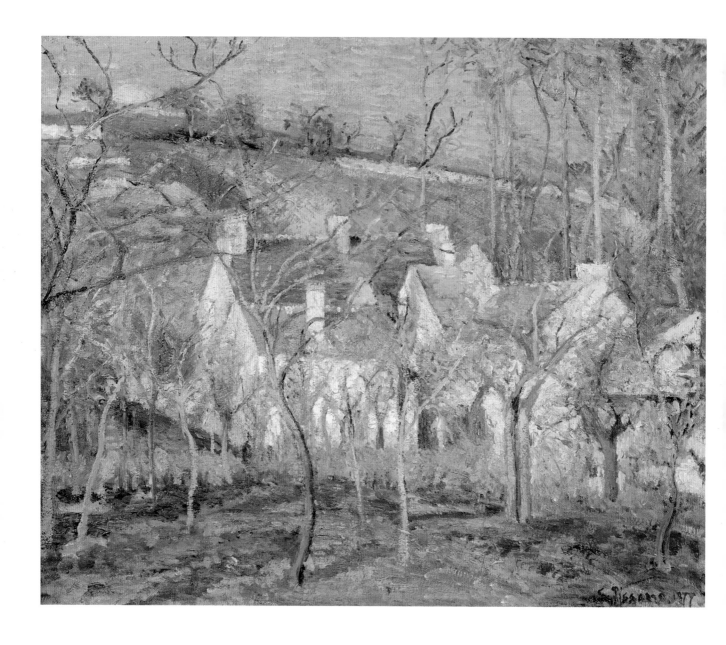

Camille Pissarro (1830–1903)
Oil on canvas, 54.5 x 65.5 cm (21½ x 25¾ in)
• Musée d'Orsay, Paris

The Red Roofs, 1877 Pissarro was bold, an artist's artist. The simplicity of this village scene is quite deceptive, as we are forced to search for the 'red roofs' here through a dense yet delicate tracery of winter trees.

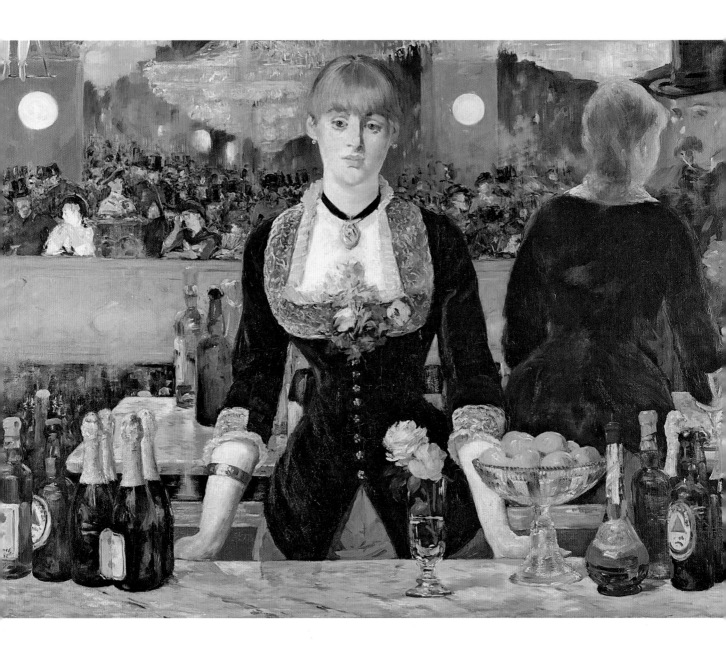

Édouard Manet (1832–83)
Oil on canvas, 96 x 130 cm (37¾ x 51¼ in)
• Courtauld Gallery, London

A Bar at the Folies Bergère, 1881–82 Pensive or sad? Alone in the babel of the bar or in conversation, as her reflection suggests? Is the gentleman a drinker or a client? Is Manet's painting a celebration or a denunciation of the *demi-monde*?

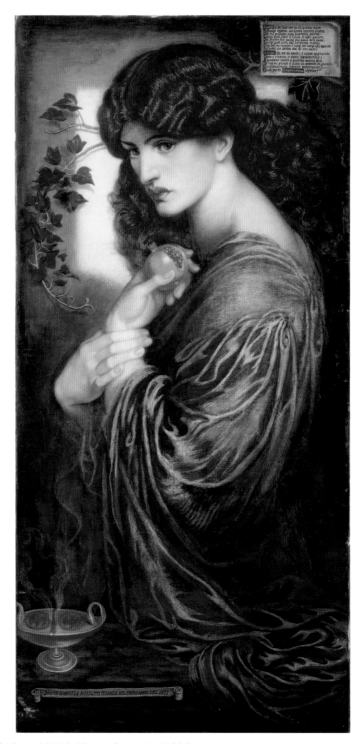

Dante Gabriel Rossetti (1828–82)
Oil on canvas, 125 x 61 cm (49¼ x 24 in)
• Private Collection

Proserpine, 1882 The bold simplicity for which Rossetti strove blazes through in this heartbreakingly poignant painting. In Greek mythology, Proserpine, daughter of Ceres, goddess of agriculture, was abducted and held in Hades by its ruler, Pluto.

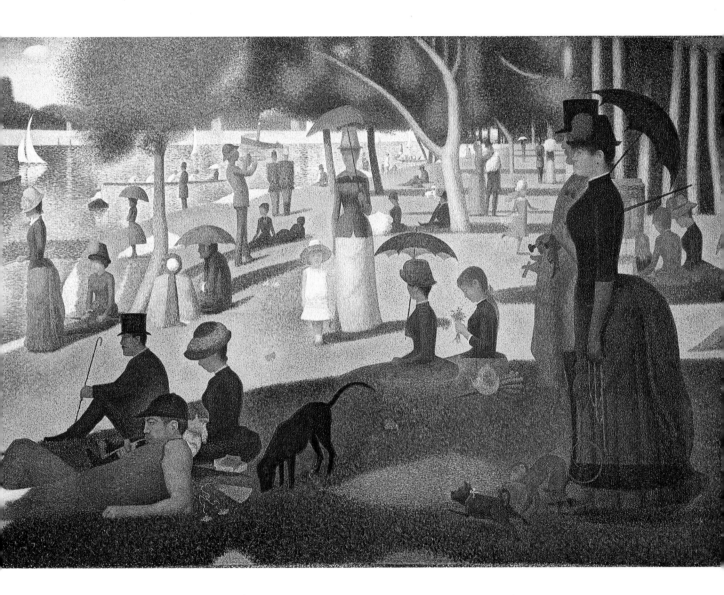

Georges Seurat (1859–91)
Oil on canvas, 207.5 x 308 cm (81¾ x 121¼ in)
• Art Institute of Chicago, Chicago

Sunday Afternoon on the Island of La Grande Jatte, 1884–86 Unique – yet surely it would have to be – Seurat's stunning canvas represents an extraordinarily audacious and original departure, but it is hard to see it as anything other than a strikingly ambitious *jeu d'ésprit*.

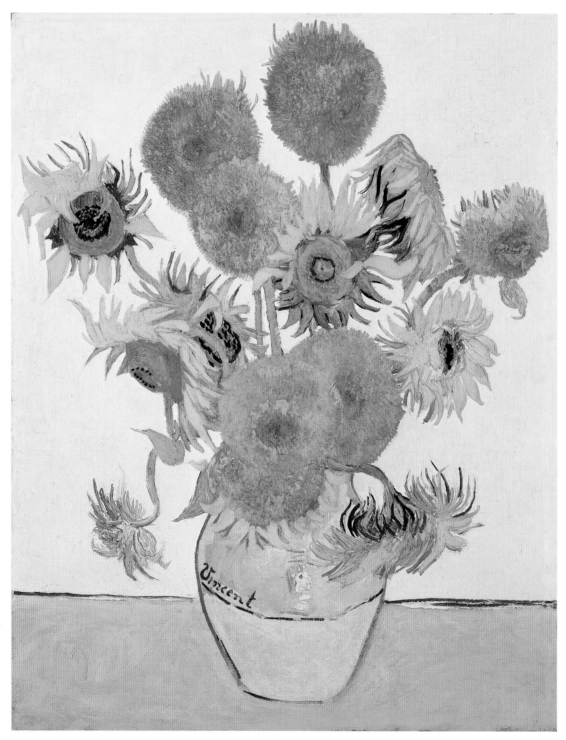

Vincent van Gogh (1853–90)
Oil on canvas, 92 x 73 cm (36¼ x 28¾ in)
• National Gallery, London

Sunflowers, 1888 Symbols of happiness and optimism – moods with which their creator is not usually associated – these sunflowers were painted for Paul Gauguin. Positively bristling and twitching with nervous energy, never did a 'still life' seem less still.

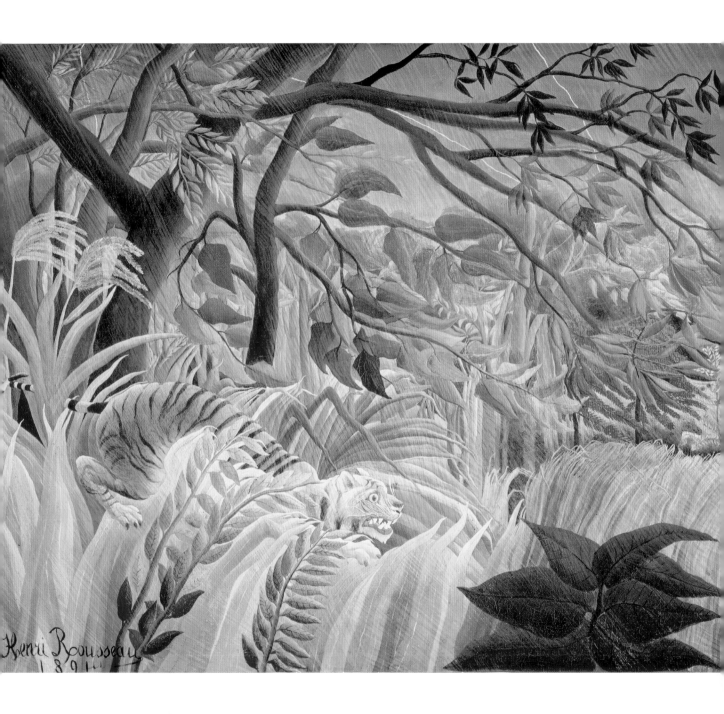

Henri Rousseau (1844–1910)
Oil on canvas, 130 x 162 cm (51 x 63¾ in)
• National Gallery, London

Surprised!, 1891 Posterity has not known what to make of Henri Rousseau, seemingly 'naïve' and yet a painter of profound sophistication. His dreamlike scenes prove surprisingly haunting, hinting at a troubling reality beyond – hence his influence on the later Surrealists.

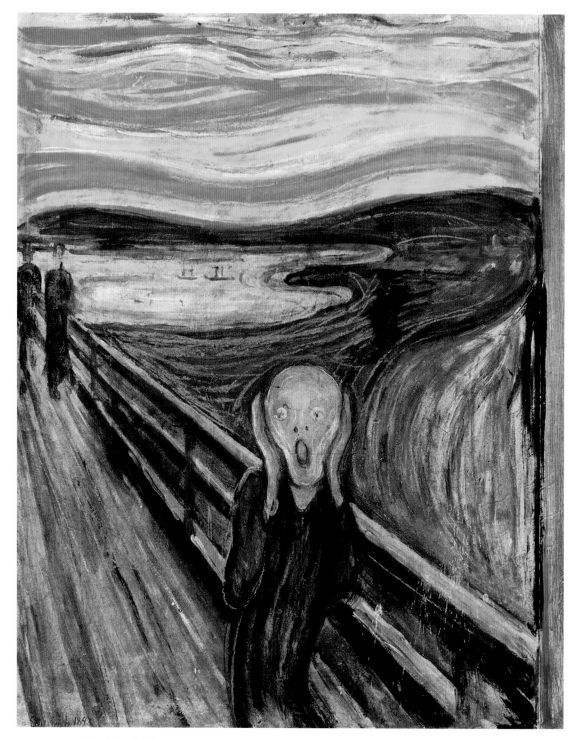

Edvard Munch (1863–1944)
Tempera and pastel on cardboard, 91 x 73.5 cm (36 x 29 in)
• Nasjonalmuseet, Oslo

The Scream, 1893 A disintegrating landscape, blood-red clouds, a shrieking sky and a human figure, its face convulsed; in Munch's vision, he said, all Nature was screaming. His picture has become iconic, the ultimate expression of modern angst.

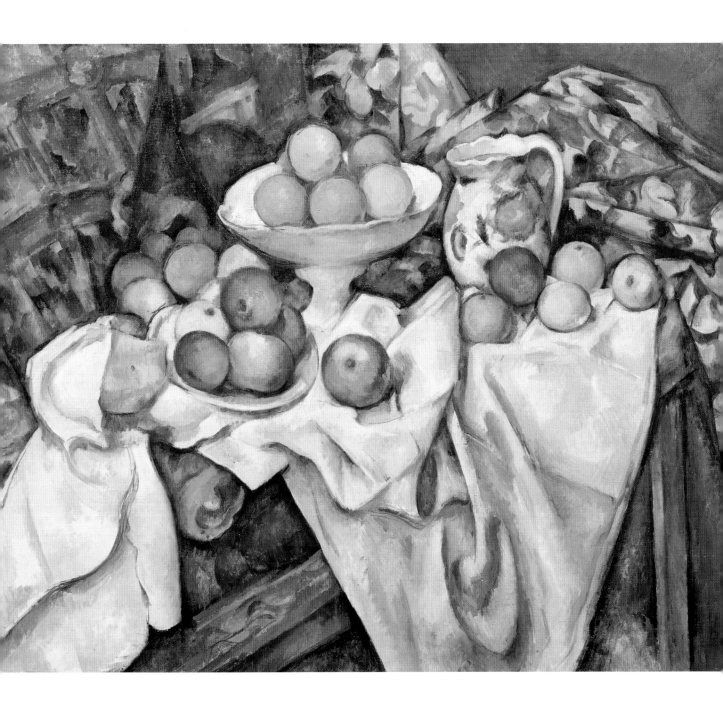

Paul Cézanne (1839–1906)
Oil on canvas, 73 x 92 cm (28¾ x 36¼ in)
• Musée d'Orsay, Paris

Apples and Oranges, *c.* **1899** Whilst colour still clearly rules the roost, Cézanne's still lifes underline his concern to transcend Impressionism, to move beyond the play of light to the evocation of form and depth in three dimensions.

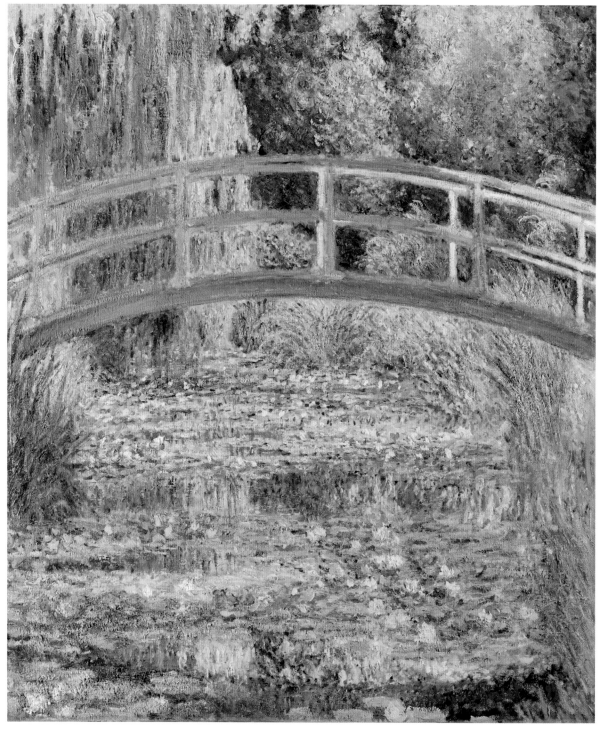

Claude Monet (1840–1926)
Oil on canvas, 88.5 x 93 cm (35 x 36½ in)
• National Gallery, London

The Water-Lily Pond, 1899 'Colour,' wrote Monet, 'is my daily obsession, my joy and my torment.'
To look at one of his great paintings is to see how colour animates our world.

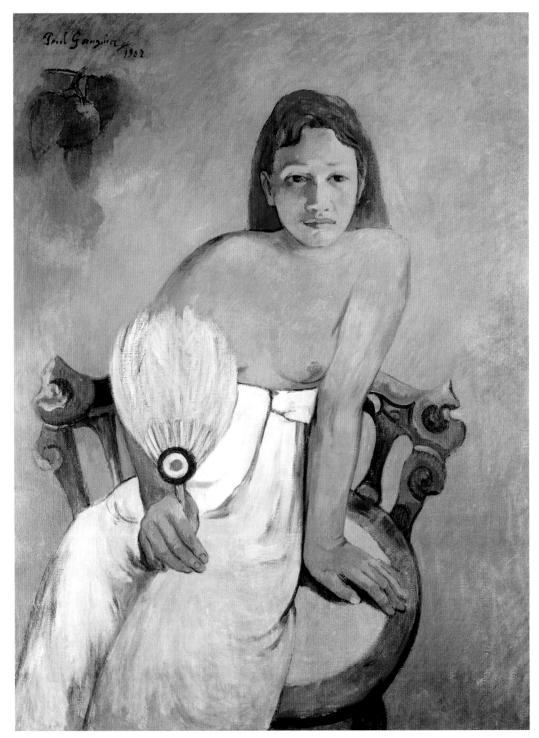

Paul Gauguin (1848–1903)
Oil on canvas, 92 x 73 cm (36 x 28¾ in)
• Museum Folkwang, Essen

Girl with a Fan, 1902 Fresh and unspoiled, and free of bourgeois shame, Gauguin's girls hold out the extravagant promise of a primeval Pacific Eden, yet they also represent a recognizable stage in the development of European art.

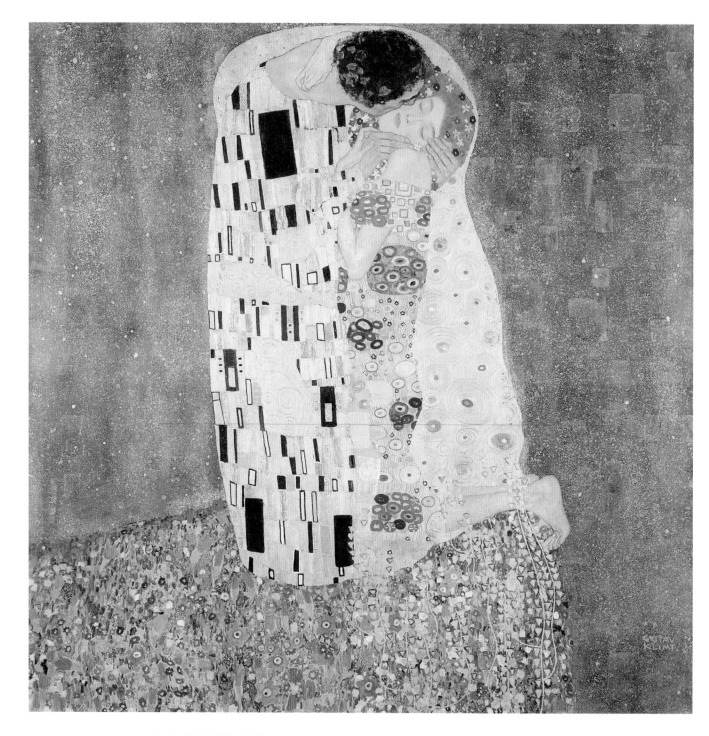

Gustav Klimt (1862–1918)
Oil and gold leaf on canvas, 180 x 180 cm (71 x 71 in)
• Österreichische Galerie Belvedere, Vienna

The Kiss, 1907–08 The 1900s saw a swing away from the straightforwardly mimetic; the robes around these clinching figures bear little resemblance to real clothes. The kiss itself is all, the gold and jewelled colours an explosion of sheer bliss.

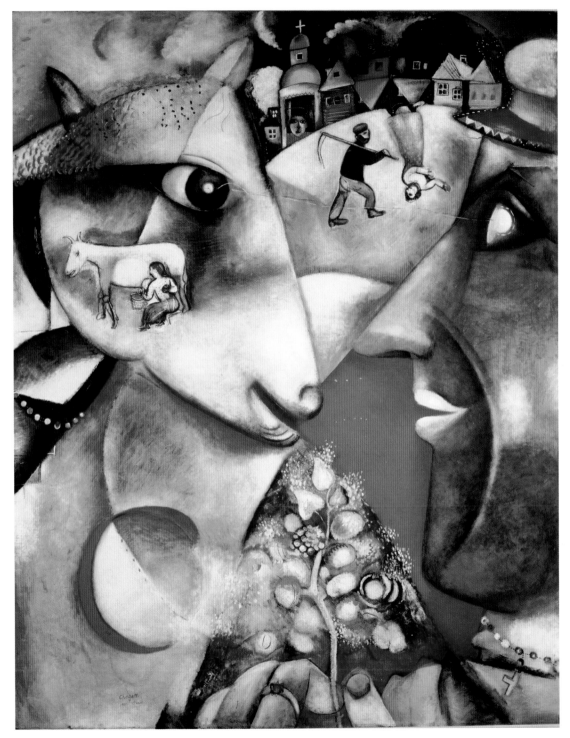

Marc Chagall (1887–1985)
Oil on canvas, 192 x 151.5 cm (75½ x 59½ in)
• Museum of Modern Art, New York

I and the Village, 1911 Myth and dream were becoming important subjects in themselves; both came together in the works of Marc Chagall, which revealed the imaginative energy pent up in the drear restrictiveness of Russian-Jewish *shtetl* life.

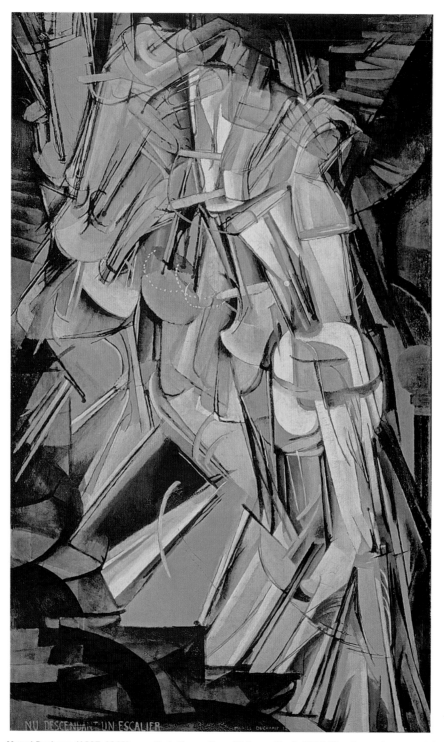

Marcel Duchamp (1887–1968)
Oil on canvas, 147 x 89 cm (58 x 35 in)
• Philadelphia Museum of Art, Philadelphia

Nude Descending a Staircase, No. 2, 1912 When is a nude not a nude? Was Duchamp's painting simply nonsense or more 'true'? Artists sensed much more to life than 'line' or even 'light' or 'colour'. How were depth and movement to be shown?

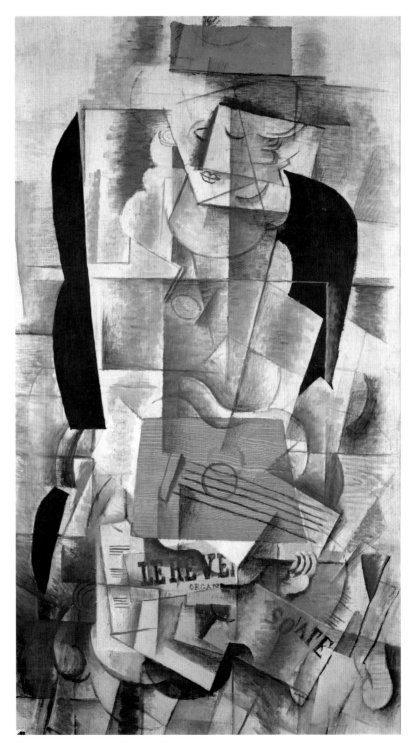

Georges Braque (1882–1963)
Oil on canvas, 130 x 73 cm (51 x 28¾ in)
• Centre Pompidou, Paris

Woman Playing a Guitar, 1913 Why should the modern artist be content to be a camera? If subjects existed in three dimensions, this should be shown. The Cubists resorted to geometric strategies to reveal reality and depth, and in the process they created enduring art.

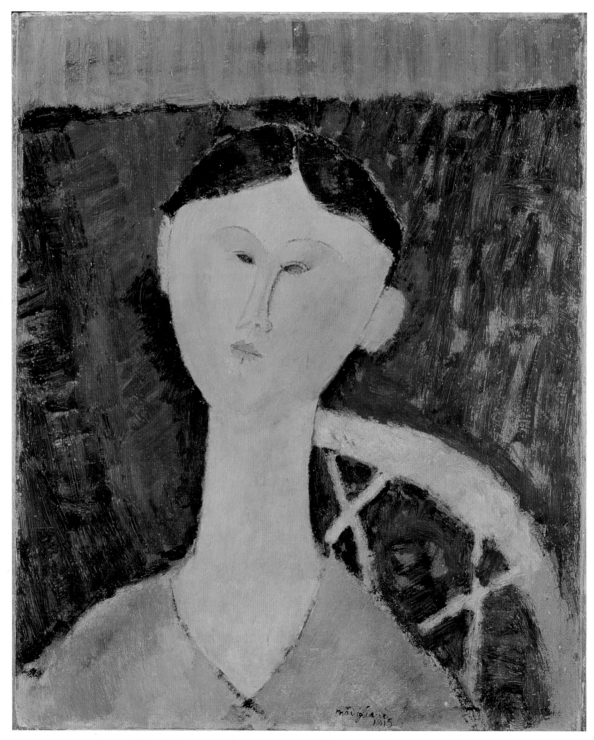

Amedeo Modigliani (1884–1920)
Oil on paperboard, 55.5 x 45.5 cm (21¾ x 18 in)
• Art Gallery of Ontario, Toronto

Portrait of Mrs Hastings, 1915 'When I know your soul,' said Modigliani, 'I will paint your eyes.' His subjects' distorted faces have a look of the African masks then in vogue in artistic Europe, suggesting the 'primitive' passions welling up within.

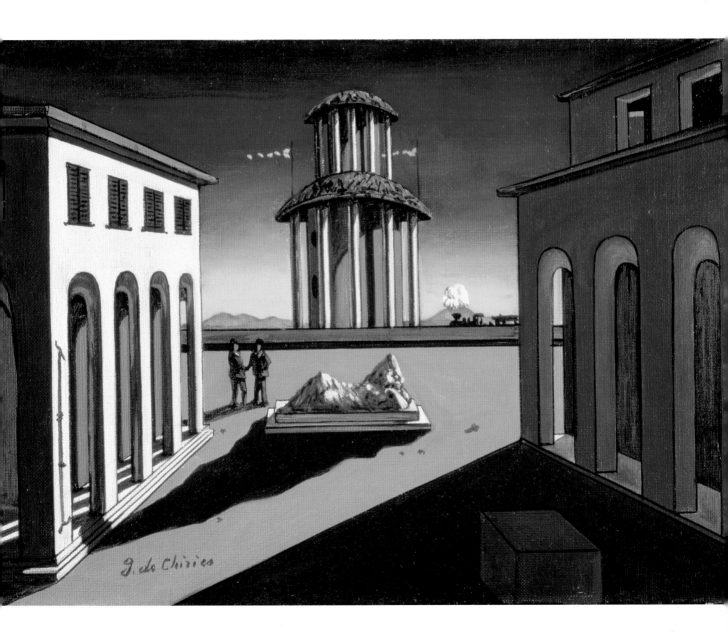

Giorgio de Chirico (1888–1978)
Oil on canvas, 35 x 25 cm (13¾ x 9¾ in)
• Art Gallery of Ontario, Toronto

Piazza d'Italia, 1913 De Chirico saw his art as 'metaphysical' – inspired by his philosophical flights *above* the realm of everyday thought – but it is easy to understand its appeal to those 'Surrealists' who sought to sound the depths of the subconscious mind.

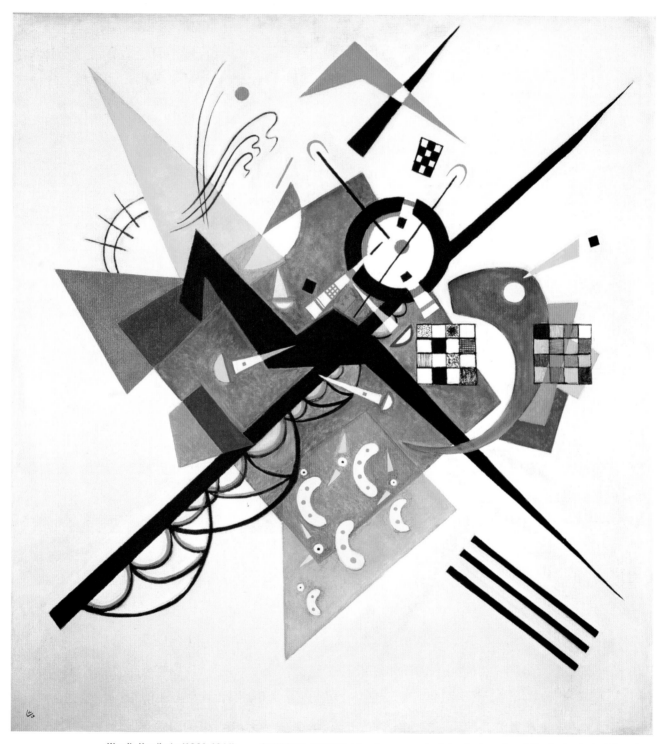

Wassily Kandinsky (1866–1944)
Oil on canvas, 105 x 98 cm (41¼ x 38½ in)
• Centre Pompidou, Paris

On White II, 1923 We are well on our way to abstraction here, though Kandinsky clearly attributed some degree of symbolic 'meaning' to his colours, the black of death irrupting into the white of life and the colours of possibility.

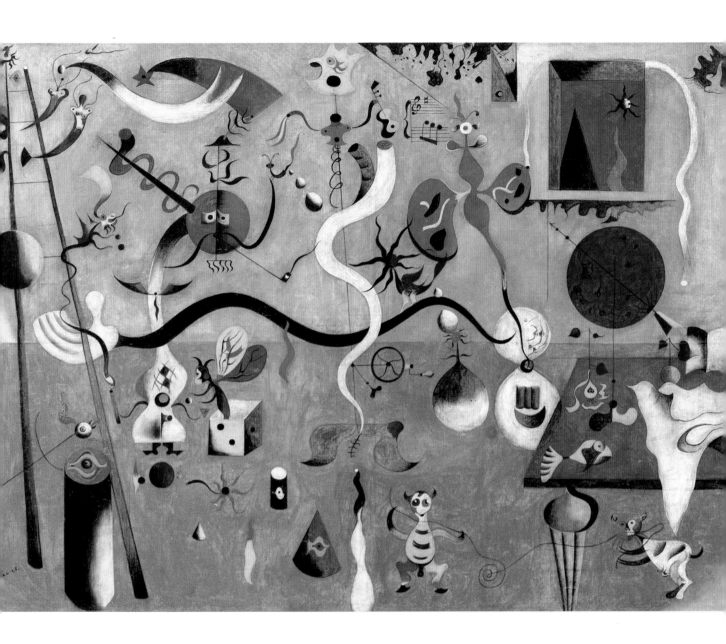

Joan Miró (1893–1983)
Oil on canvas, 66 x 90.5 cm (26 x 35½ in)
• Albright-Knox Art Gallery, Buffalo

Harlequin's Carnival, 1924–25 'The painting rises from the brushstrokes as a poem rises from the words. The meaning comes later,' Miró claimed. The influence of medieval visionaries such as Bosch may be seen in works like this, though they doggedly resist interpretation.

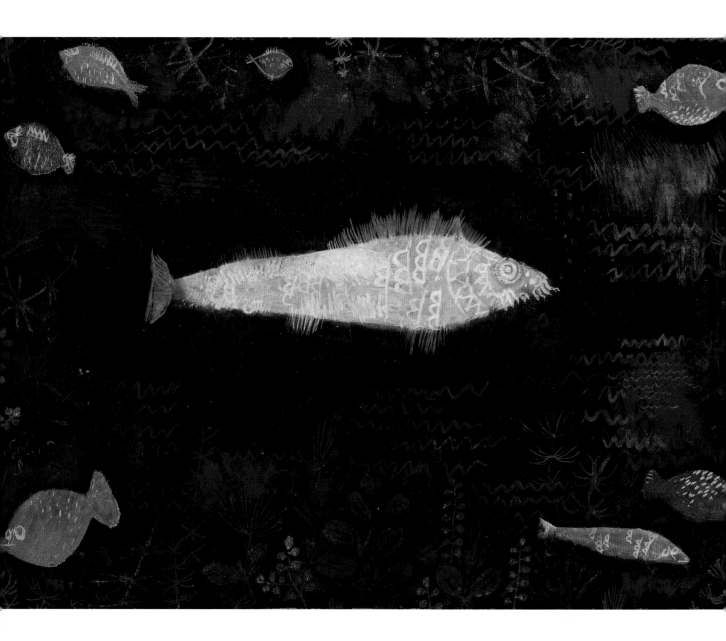

Paul Klee (1879–1940)
Oil and watercolour on paper on cardboard,
69 x 49.5 cm (27¼ x 19½ in) • Hamburger Kunsthalle, Hamburg

The Goldfish (No. 86), 1925 Artists of the 1920s worried away at the relationship between the real and the surreal, the conscious and subconscious mind, and German painters like Paul Klee were no exception.

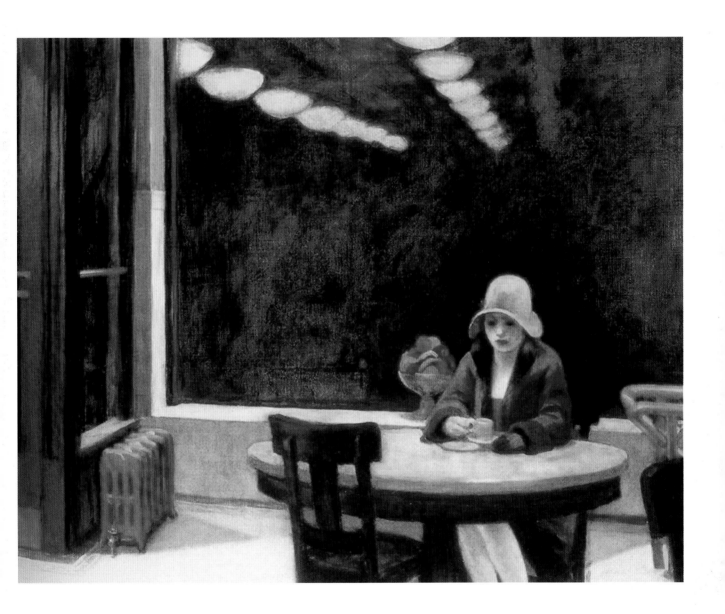

Edward Hopper (1882–1967)
Oil on canvas, 71.5 x 91.5 cm (28 x 36 in)
• Des Moines Art Center, Des Moines

Automat, 1927 Flatly realistic though they were in style, Hopper's studies in isolation hinted at an inexpressible melancholy beyond. In this way they obliquely addressed those same subconscious anxieties that were addressed more directly in European Surrealist art.

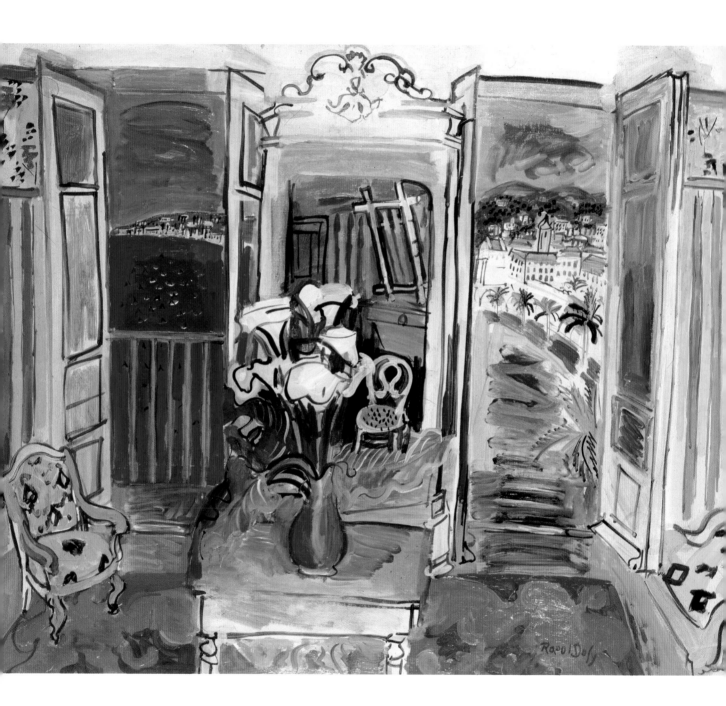

Raoul Dufy (1877–1953)
Oil on canvas, 66 x 82 cm (26 x 32¼ in)
• Galerie Daniel Malingue, Paris

Interior with Open Windows, 1928 'The subject itself is of no account,' said Dufy, 'What matters is the way it is presented.' The rebellion of the Fauves may be seen as a radical rejection of art's supposed duty to depict, to represent.

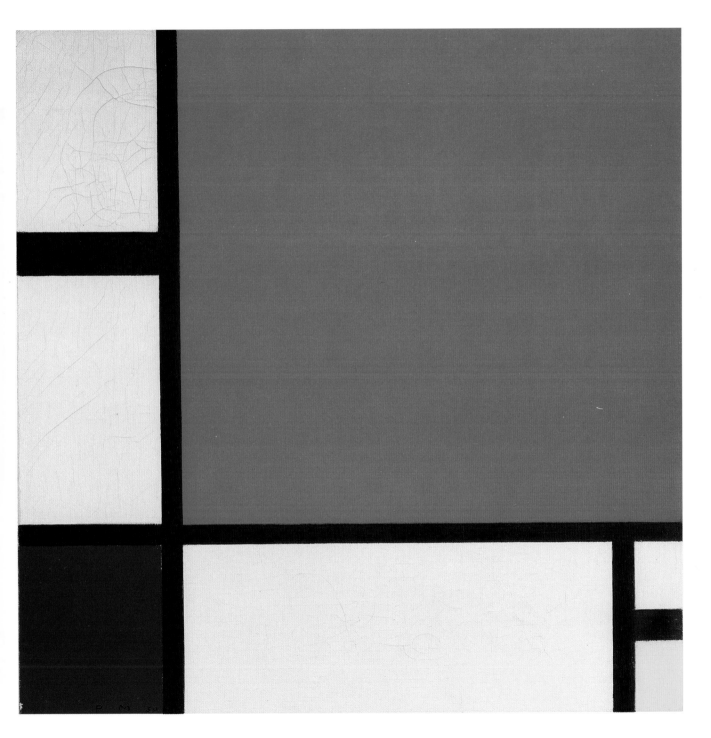

Piet Mondrian (1872–1944)
Oil on canvas, 46 x 46 cm (18 x 18 in)
• Private Collection, Giraudon

Composition with Red, Blue and Yellow, 1930 Pure colours, clean lines and – most emphatically – no object. In Mondrian's view, representation in art was just the accumulation of so much clutter; to attain the 'emotion' of beauty, the object itself had to be purged.

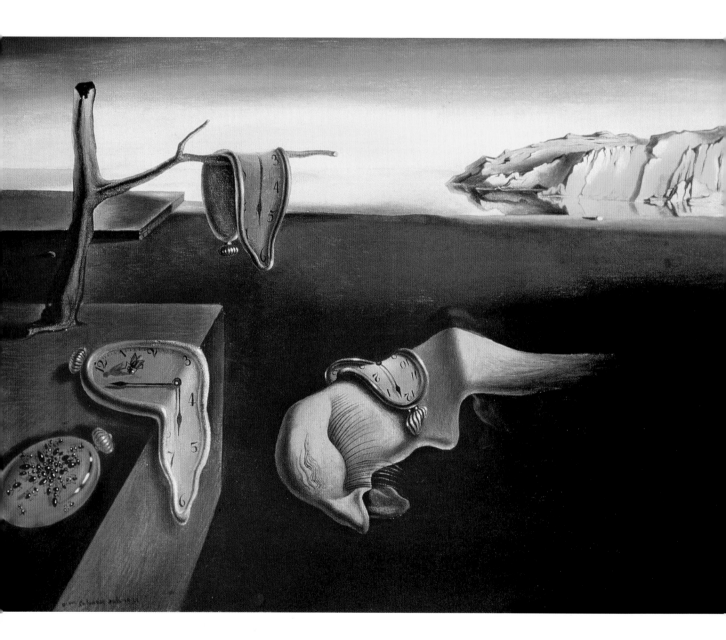

Salvador Dalí (1904–89)
Oil on canvas, 24 x 33 cm (9½ x 13 in)
• Museum of Modern Art, New York

The Persistence of Memory, 1931 Surrealism was utterly serious in its efforts to explore aspects of reality beyond the conscious and the tangible. Dalí's melting clocks show the effects of human memory in transcending time.

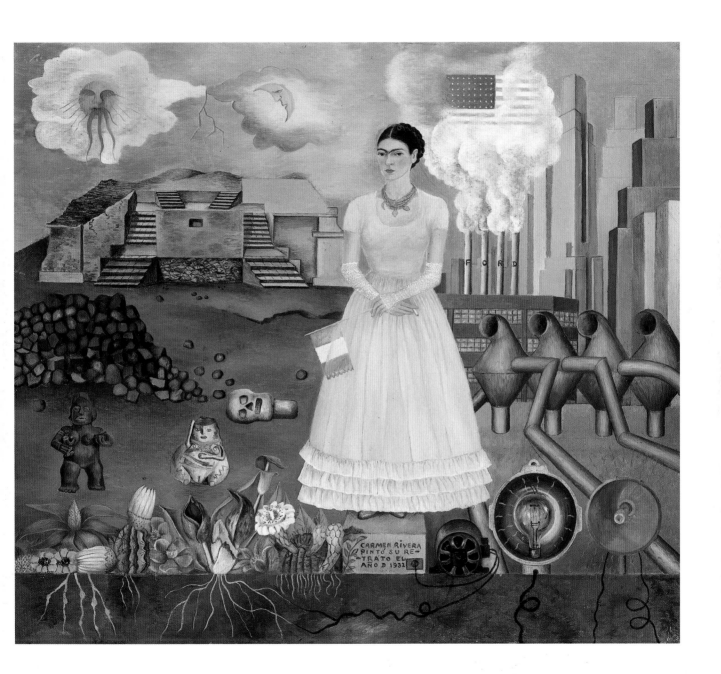

Frida Kahlo (1907–54)
Oil on metal, 31.7 x 35 cm (12½ x 13¾ in)
• Private Collection

Self-Portrait on the Borderline between Mexico and the United States, 1932 Kahlo was a pioneering spirit, her work a powerful statement on behalf not just of women but of all those nations and cultures excluded from an established 'art world' centred on Europe and North America.

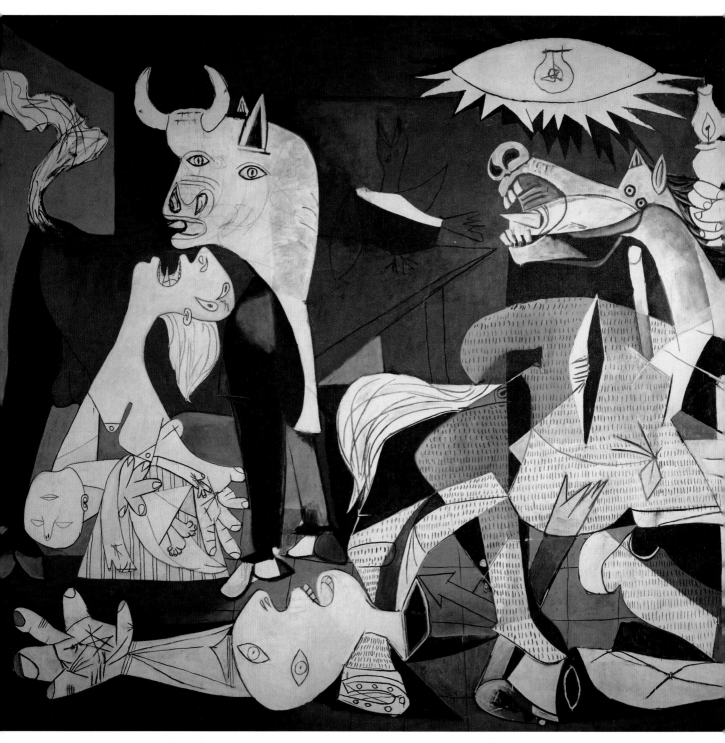

Pablo Picasso (1881–1973)
Oil on canvas, 349 x 776 cm (137½ x 305½ in)
• Museo Nacional Centro de Arte Reina Sofía, Madrid

Guernica, 1937 The bombing of this Basque village by General Franco's German allies inspired the greatest-ever work of protest art. Picasso's painting also proved that modern art could communicate and resonate emotionally with ordinary people around the world.

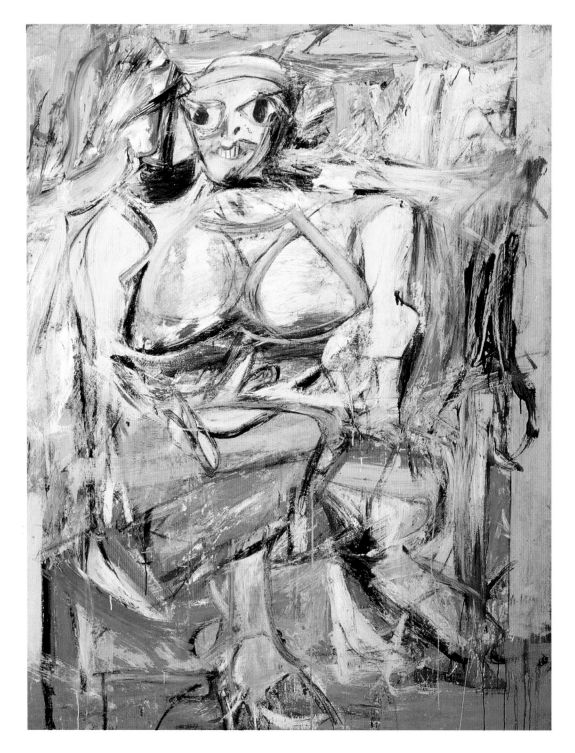

Willem de Kooning (1904–97)
Oil on canvas, 193 x 147 cm (76 x 58 in)
• Museum of Modern Art, New York

Woman I, 1950–52 de Kooning brought the Abstract Expressionist wheel full circle, reintroducing representation in an influential sequence of 'women' with a Primitivist air, all brought into being through the haphazard techniques of 'action painting'.

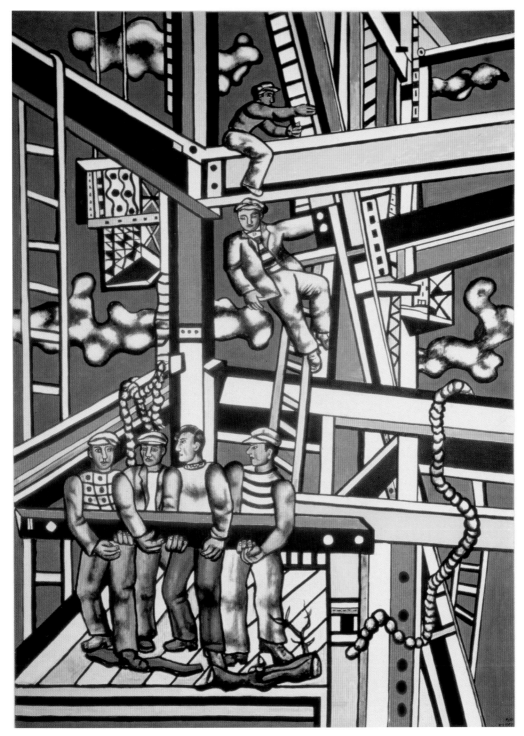

Fernand Léger (1881–1955)
Oil on canvas, 300 x 200 cm (118 x 78¾ in)
• Musée Fernand Léger, Biot

The Constructors, 1950 Léger's left-wing views convinced him that art should not only represent those who built society but also reach them. These cartoonlike characters and comic-strip colour schemes point the way from 'popular' to the later 'Pop'.

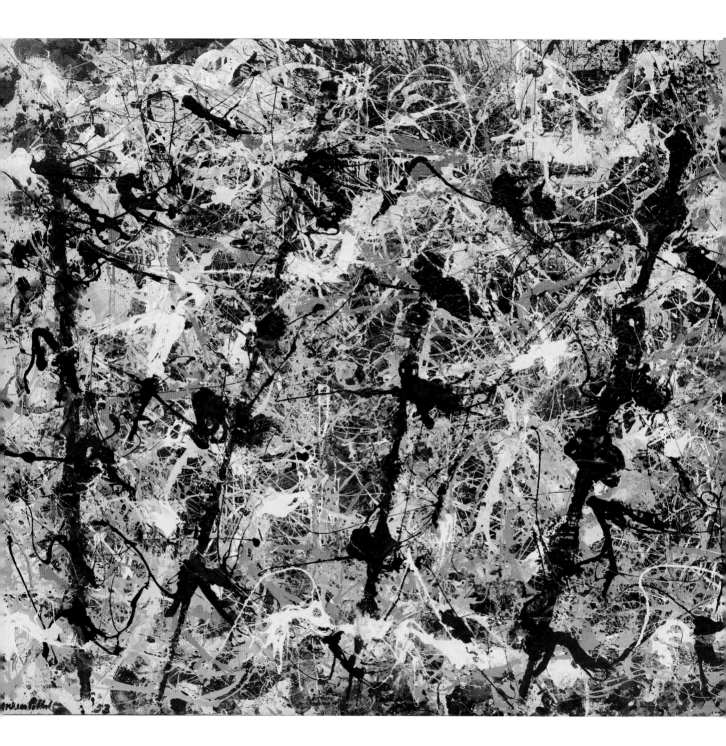

Jackson Pollock (1912–56)
Enamel, aluminium paint and glass on canvas,
210 x 490 cm (82¾ x 193 in) • National Gallery of Australia, Canberra

Blue Poles, 1952 This painting has acquired a certain improbable celebrity since it first appeared. Its fame as a flagship work of Abstract Expressionism is proof that the public can respond to truly uncompromising modern art.

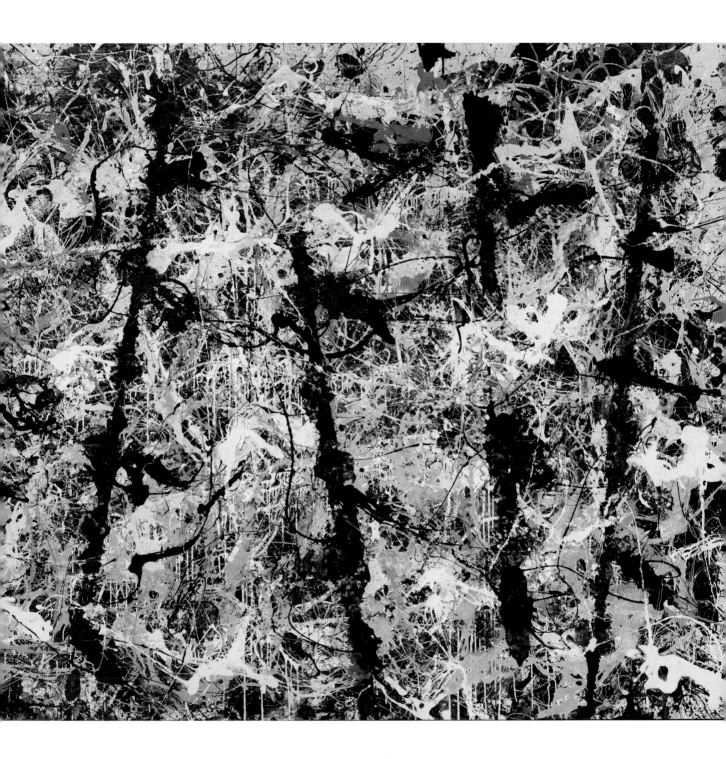

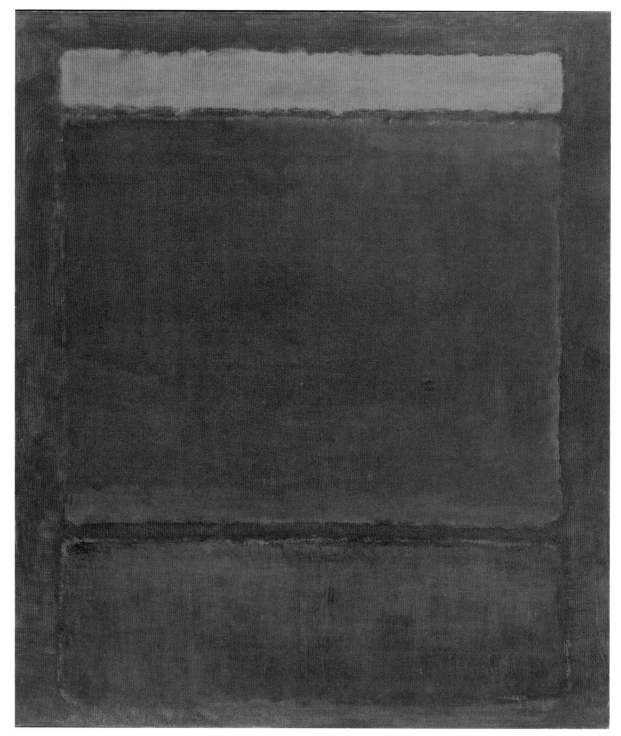

Mark Rothko (1903–70)
Oil on canvas, 324 x 200 cm (127½ x 78¾ in)
• Museum of Fine Arts, Houston

Painting, 1961 'Pictures must be miraculous,' Rothko once observed. He had an Orthodox Jewish background, and retained a spiritual side. He was drawn to 'Color Field' painting precisely because its uninterrupted expanses of colour seemed to suggest transcendence.

Roy Lichtenstein (1923–97)
Oil and magna on canvas, 172 x 203.5 cm (67¾ x 80 in)
• Scottish National Gallery of Modern Art, Edinburgh

In the Car, 1963 Lichtenstein was fascinated by commercial art more as industrial process than as aesthetic. Hence his love of the comic strip and the 'Ben-Day dots' of which its images were composed.

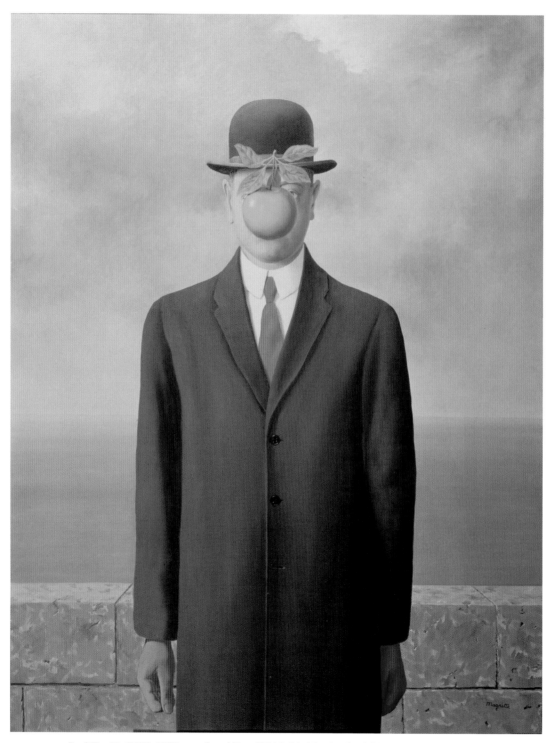

René Magritte (1898–1967)
Oil on canvas, 116 x 89 cm (45½ x 35 in)
• Private Collection

Son of Man, 1964 Is this Adam in a bowler? Is the apple we (and he) strain to see around the fruit of the tree of knowledge and our human curiosity? Who knows? And who hopes to fathom a Surrealist classic?

Andy Warhol (1928–87)
Screen print, 87.5 x 54 cm (34½ x 21¼ in)
• Wolverhampton Art Gallery, Wolverhampton

Campbell's Soup Can, 1968 Pop set out to represent the products of the consumer culture as true art, revelling in the trite and the mass-produced. What was wrong, Warhol wondered, with a soup tin as a subject?

Indexes

Index of Works

Page numbers in *italics* refer to
illustration captions.

General Index

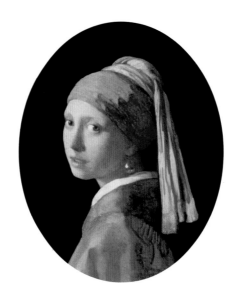

Masterpieces of Art
FLAME TREE PUBLISHING
A new series of carefully curated print and digital books covering the world's greatest art, artists and art movements.